IMAGES
of America

CLAYTON

IMAGES
of America

CLAYTON

Verda S. Corbin and Shane A. Hutchinson

ARCADIA
PUBLISHING

Copyright © 1998 by Verda S. Corbin and Shane A. Hutchinson
ISBN 978-0-7385-6305-3

Published by Arcadia Publishing
Charleston SC, Chicago IL, Portsmouth NH, San Francisco CA

Printed in the United States of America

Library of Congress Catalog Card Number: 2008925220

For all general information contact Arcadia Publishing at:
Telephone 843-853-2070
Fax 843-853-0044
E-mail sales@arcadiapublishing.com
For customer service and orders:
Toll-Free 1-888-313-2665

Visit us on the Internet at www.arcadiapublishing.com

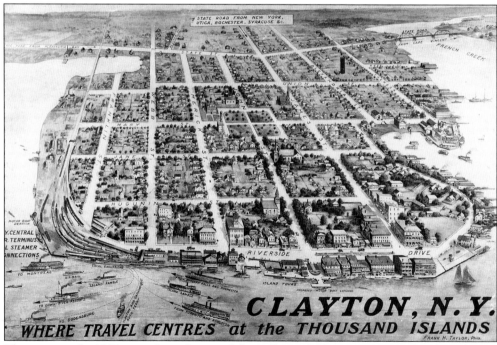

This is an early 1900s artist's rendition of the village of Clayton, New York. The Clayton Chamber of Commerce first formed in 1926, and used this painting in its initial promotional publication. The artwork was used again in 1993 to create a walking tour map of the village. The print itself is undated and is believed to have been produced after 1909 (Hubbard annex not shown). The artist is Frank Taylor of Philadelphia, Pennsylvania. Taylor spent his summers at "Shady Ledge" on Round Island.

CONTENTS

Introduction 7

1. Clayton's Early Years 9

2. Business and the Downtown District 25

3. Village Hotels 47

4. Summers of Tourism 59

5. In the Islands 73

6. Winter in Clayton 89

7. The Village Community 99

8. The People of Clayton 115

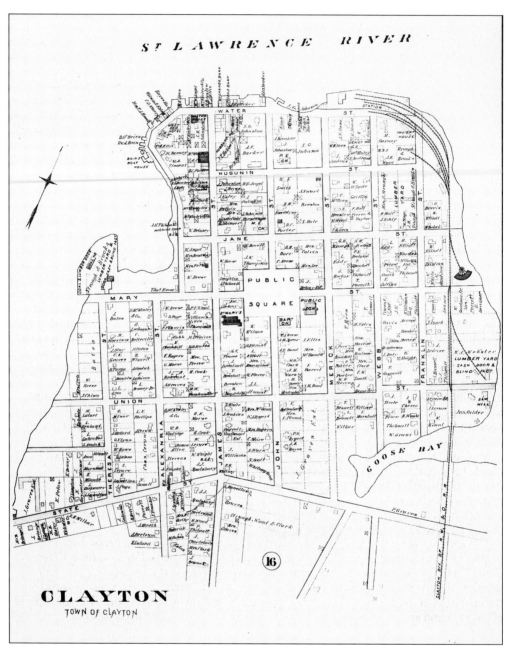

CLAYTON

TOWN OF CLAYTON

Originally, the Oneidas knew the area as Weteringhera-Guentere. It would later be known as French Creek and Cornelia before the New York State legislature would create the Township of Clayton. Clayton was named after U.S. Sen. John M. Clayton in 1833. The Village of Clayton was incorporated with a vote of 140 in favor, and 51 against, after a citizen meeting at the Walton House on April 17, 1872. The map shown is dated 1888.

INTRODUCTION

The town of Clayton was established on the shores of the St. Lawrence River in northern New York State. At the turn of the last century, Clayton was in its heyday and was one of the most famous resort destinations in the northeastern United States. During this period, Clayton was a place of affluence. Its economy and culture were built on timber trade, shipping, boat building, and tourism.

The history of Clayton has been captured in many ways. One person who preserved this history was Les Corbin. His avenue of historic preservation was through photography. This book, in the Images of America series, is a representation of Clayton as seen through the photographic history in the Les Corbin collection.

Mr. Corbin, known as the "Dean of the Thousand Islands Photographers," dedicated his life to compiling the photographic history of Clayton and the surrounding Thousand Islands region. Whether taking his own photographs or restoring the collections of those photographers before him, Mr. Corbin was able to develop one of the most extensive collections in the area. Every photograph in this book has been produced from an original glass plate or negative found in the collection.

The authors of this book, Verda S. Corbin and Shane A. Hutchinson, are owners of Corbin's River Heritage, a photography gallery and bookstore located in downtown Clayton. Verda Corbin, wife of the late Les Corbin, has been involved in the business for over four decades. Verda's grandson, Shane Hutchinson, moved to Clayton two years ago to assist with the operation of the business. This year Verda and Shane are celebrating the 50th anniversary of Corbin's and are releasing this book as a tribute to Les Corbin and his collection.

ACKNOWLEDGMENTS

Most of the information used in this publication came straight from the notes and files of Les Corbin. However, we do need to acknowledge and give special thanks to the Hawn Memorial Library of Clayton. The library archives were an invaluable resource when researching chronological histories.

We would also like to thank Harold Kendall, Virginia Minnick, Eva Rexford, Linda Schleher, and Phoebe Tritton for their assistance in making this project possible. Their extensive knowledge of local history proved to be priceless.

Lastly, we would like to thank Juliane Bauer for countless hours of typing, editing, and support.

Verda S. Corbin
Shane A. Hutchinson

One

CLAYTON'S
EARLY YEARS

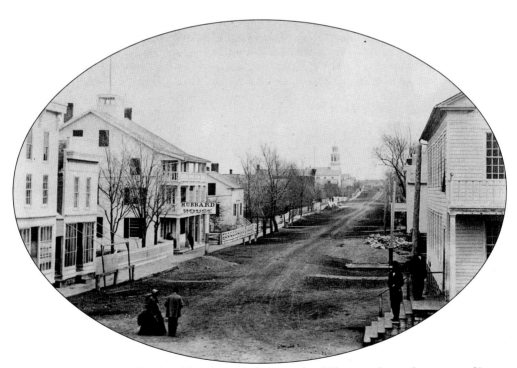

This photograph, probably the oldest-known photograph of Clayton, shows the corner of James Street and Water Street. In the 1860s, this corner of the village was a hub for travelers and journeymen arriving to Clayton for work and play. Hotels were located on both sides of James Street. Located on or around this corner in 1860 were the old Northern Hotel, the White House, and the Hubbard House.

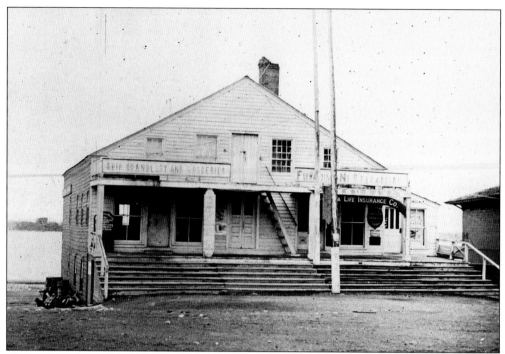

Clayton's early commercial shipping centered around "The Warehouse." The building was built in 1831 and stood for about 80 years adjacent to today's Centennial Park at the end of the downtown parking square. It was erected from timber and lumber cut within the township. After reviewing an account book of the 1850s, it would appear that there might have been a sail-loft upstairs. Rees was the owner, and was connected with the Calvin rafting and shipping business.

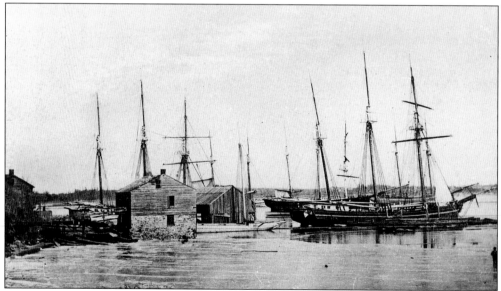

Clayton's early industrial roots were in timber and rafting. The business extended around the western shore of the village to Mary Street and the site of the present day Antique Boat Museum. The building in the foreground was believed to have housed the village jail.

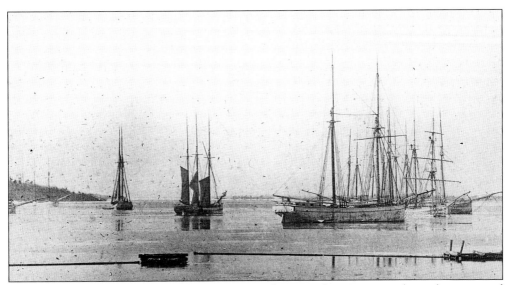

"Horse Piers," called so because horses were used to run the capstan and winch, were used in unloading of timber from the larger sailing vessels. The timber business would decline in the mid-1800s when the United States Congress would impose duties on Canadian lumber. As the 1800s progressed, Clayton's shipbuilding industry would develop as the next prominent local industry.

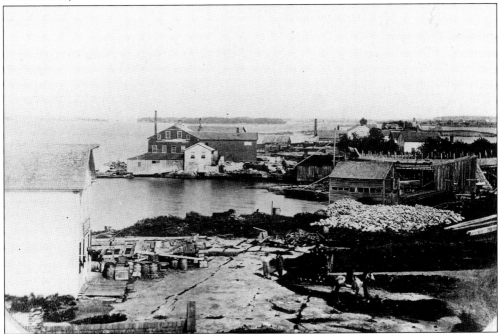

This photograph is another of the oldest pictures of downtown Clayton. Pictured is Clayton's shipyard on Water Street (current location of the Thousand Islands Museum and town offices). The bay used in launching boats was filled in and is now Riverside Drive. The shipyard extended a full block southward to Hugunin Street and operated until the late 1880s. Both schooners and steamships were built here under various ownership (Smith, Fowler, Merrick, Esselstyne, Oades, and Johnston).

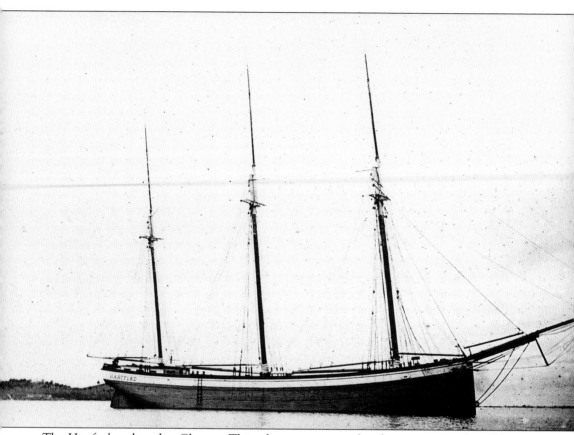

The *Hartford* anchored at Clayton. This schooner, captained and carrying crew from Clayton, made many successful runs through the Great Lakes before sinking in Mexico Bay on Lake Ontario during a violent storm on October 11, 1894.

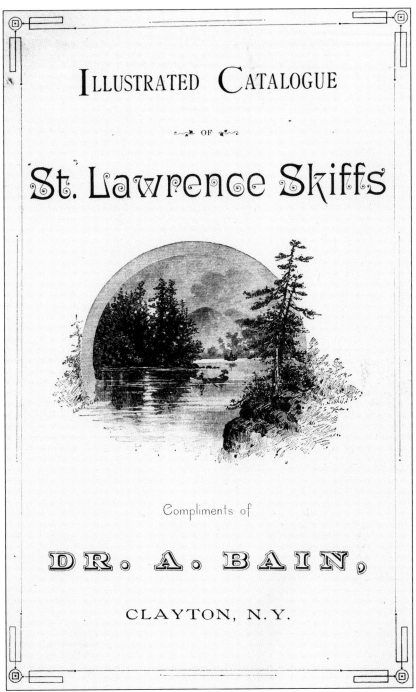

Illustrated Catalogue

❦ OF ❦

St. Lawrence Skiffs

Compliments of

DR. A. BAIN,

CLAYTON, N.Y.

Unique to our region, and in the world of boating, is the St. Lawrence Skiff. The St. Lawrence Skiff, developed primarily as a guide's work boat, was used to take fishing parties to and from "hot" fishing spots in the Thousand Islands. The local tradition says that the first skiff was built in Clayton around 1864 by Xavier Colon. Pictured is the cover of Dr. A. Bain's *Illustrated Catalog of St. Lawrence Skiffs*, (c. 1884). Dr. Bain acquired Colon's original business and later operated business for himself in Clayton and at Thousand Island Park on Wellesley Island.

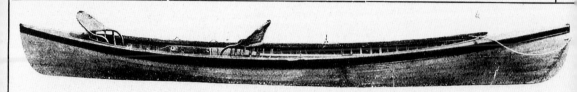
Other Clayton builders of the St. Lawrence Skiff included Wilbur and Wheelock. They operated out of a riverfront building on Water Street. Pictured is an advertisement for their skiffs and canoes.

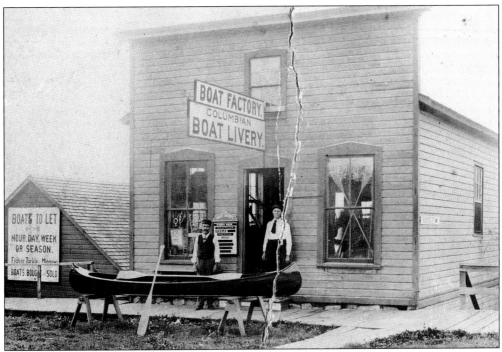

This is the outside of the boat livery where Wilbur & Wheelock Skiffs and Canoes were built and sold. The current location of this building is adjacent to the village docks at the U.S. Customs and Immigration office on Riverside Drive. Pictured on the right is Charles Wilbur.

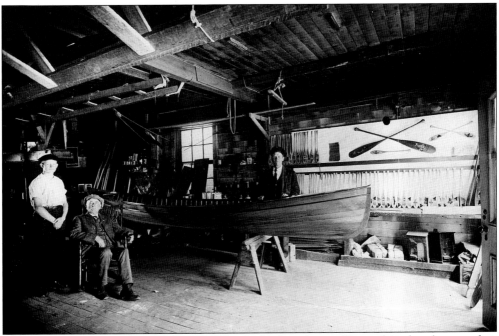

This view is of the inside of Wilbur & Wheelock's boat livery. Pictured in the photograph is Charles Wilbur (standing behind the skiff), his son, Leon Wilbur, and Hiram Mount (seated in the chair).

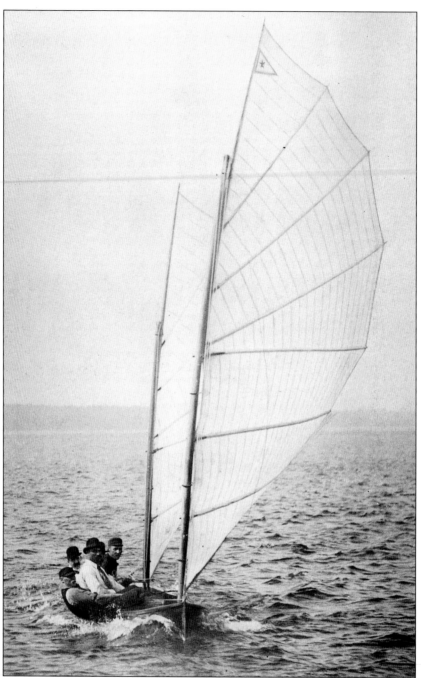

The batwing sailing skiff races were pictured here *c.* 1890. When skiff racing became an organized sport in the Thousand Islands (late 1880s), the unfair advantage some boats held over others because of hull and sail size created ill feelings, and fights often ensued after the races. In an attempt to remedy this, the local racing association created standards for competitions in 1890. "Finally it was agreed that any skiff, to compete in the races of this association, must be sharp at both ends, with no counter stern or transom." In addition, the hull was built so that the extreme length when multiplied by the extreme beam would come close to 88 feet.

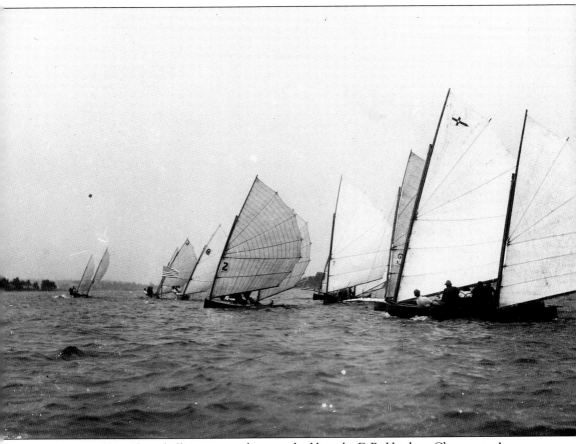

The batwing 88 sailing skiff races were photographed here by D.R. Hardy at Clayton on August 1, 1891. This type of boat drew from 5 to 9 inches of water and eventually carried from 350 to 400 square feet of sail in the shape of an S-wing batten sail of a bat. A quote from *On the St. Lawrence*, dated July 16, 1891, reads, "The St. Lawrence Skiff Sailing Association has perfected arrangements for the fourth of the championship races for the association pennant and fixed upon Saturday, August 1 for the date."

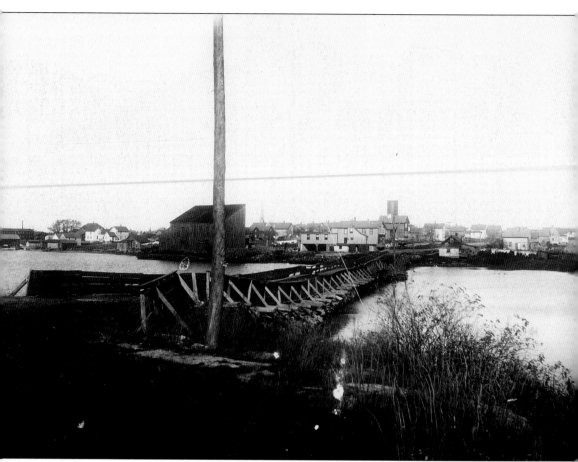

The Old Stone Bridge over French Creek, originally built in 1835, was replaced by a three-span steel suspension bridge in 1908. That bridge has since been replaced with the present-day construction.

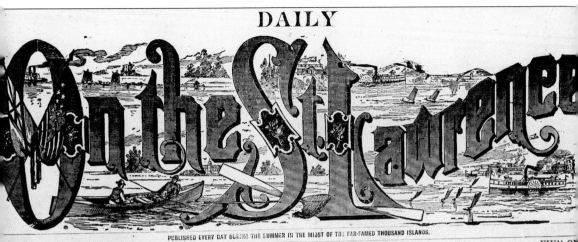

DAILY
On the St. Lawrence

PUBLISHED EVERY DAY DURING THE SUMMER IN THE MIDST OF THE FAR-FAMED THOUSAND ISLANDS.

VOLUME I. NO. 31. | CLAYTON, N. Y., SATURDAY AUGUST 15, 1891. | FIVE C

ILING THE DAYS AWAY.

CROWDS ARE HERE.

oying the Cool Breezes of the Blue St.
wrence, Interesting Items From Hotel
ttage and Camp—A Score of Society
tes.

dge Williams, of Watertown, is on
River.

iss Addie Steele, of Utica, is at the
usand Island Park.

ill Carlton will spend September at
usand Island Park.

he steamer New Island Wanderer
ried a good sized crowd last night.

, D. Lowe and family are at Thous-
Island Park for a few days' outing.

W. C. Root, of Carthage, is enjoying a
days' outing at Thousand Island
k.

Mrs. Fred Walts, of Cape Vincent, is
ting at the Bullock cottage, Round
nd.

essrs. John and Frank Williams, of
ca, arrived yesterday for a few days'
t at Thousand Island Park.

iss Neil Gilmore, of Albany, leaves
morning for Utica, en route for
ne. Mrs. J. Wicks accompanies her.
liss Lillian Stunden, of Gananoque
fascinating young lady who is the

NEW CONGREGATIONAL CHURCH.

The Handsome House of Worship Now
Building.

The cut given is from the front eleva-
tion of the new Congregational church
now building at Clayton, N. Y. This
church was organized March 17th, 1890,
with thirty-five charter members, and
has since doubled its membership.

It has a sabbath school of about one
hundred members, and a large and
flourishing Young Peoples' Society of
Christian Endeavor.

At the time of organization the church
secured the only hall in the village, a
small hall over the front of the post-
office building. As this was the best
place obtainable it soon became evident
that a very small growth would neces-
sitate the building of a church, and that
at an early date.

To do this and pay its current expen-
ses was acknowledged to be a great un-
dertaking, if a church was built in keep-
ing with our village as a summer resort

who read this they cordially invite con-
tributions, in such amount as will be
freely paid. Checks sent to the clerk of
the Congregational church, will be
promptly acknowledged and greatly ap-
preciated.

THE WANDERER

Comments on Thousand Island Park
Matters.

A vast amount of wisdom is daily let
loose around the new Park hotel as to
the best method of constructing hotels,
and much valuable information is freely
given as to how the different portions of
the work should be done. It is unfor-
tunate that all this counsel can not be
heeded, but one of the best architects in
the state having been employed and
contractors of many years' experience
in building, to say nothing of the build-
ing committee, whose general informa-
tion on all subjects is unparalleled, it
seems reasonable to hope and expect
that this conglomeration of wisdom will
be capable of producing a tolerably fair
hotel. Should it be otherwise and the
hotel fail to give satisfaction, it will be
a comparatively easy matter to slide it
into the River and build another. Let
those who detect so many grave errors
in the building be comforted by this
thought.

GOSSIP ABOUT THE ISLANDS.

SOCIETY CHAT.

The Man Who Owns an Island is Monarch
of All He Surveys—What Ada Marie Peck
Writes from the River—Lovely Children.

Speaking of children—there are such
lovely children and young girls here!
Among the latter, little Miss Seeley may
be mentioned as a type of the coming
young American woman, so simple and
unaffected, with a charming courtesy
toward every one. If our young girls
could only be impressed with the fact
that no beauty of person can be truly
beautiful without the graciousness of
manner which springs from a kindly
heart rather than from a book of etiquet,
I am sure they would try to cultivate
it.

Among the lovely children is Gladys
Bottman, a dear little girl with a curl-
ing mass of red gold hair, who comes
into the parlors at the children's hour
and dances in her quaint greenway
frock with that unconsciousness of ob-
servation which makes children so
delightful. A bright, manly boy with
a sweet face is Leopold Leventritt, Hon.
David Leventritt, counsel for Tammany
and family are at this resort. Miss
Leventritt is among the much admired
young ladies.

AT THE HOTELS.

The People Who Arrived on the St.
Lawrence Yesterday.

HUBBARD HOUSE

John S Stottes, W A Linn and wife,
A V Young, R S Aair, New York; C K
Wright and wife, Miss N B Wright, Post-
ville; Miss M Morse, Rochester; Wm
Wippert, Miss Kerr, Edward Barn-
hardt, J W Bush, Miss Bush, G B Web-
ster and wife, Miss Ovens, Buffalo; W
S Warder and wife, Florence Varnum,
Erie, Pa; H A Moore, Ogdensburg; L H
Burns and wife, Dayton, O, J H Wal-
rath, Randy Hogue, Syracuse; J A
Cummings, Binghamton; J Mullin, C P
Walts, Watertown; B Warner, Chau-
mont; A D Miller, New Haven, Conn;
O; G H Stengel, W E Moses, A J Bish-
ler, M Miller, Pittsburg; W E Sennott,
Boston; T B Allen and wife, Brooklyn;
W A Rowlands, Utica; L J Kingsley,
Binghamton; C E Sitchener, Bingham-
ton; Mrs E H Myers, Carthage; G de
Cordova and wife, Brooklyn; John Ter-
willeger, Amsterdam; R W Bailey,
Pottsdam, Pa.

WALTON HOUSE.

W C Phelps, J R Currie and wife, Maj
Thibault and wife, New York; P B
Frink, Hillsboro O; W W VanWinkle,
Miss VanWinkle, Parkersburg W Va; A
Y Kelly and wife, St. Louis; Clark Olds

EIGHTY-THREE GOLDEN

GRANDMA PULLMAN

Birthday Appropriately Obse
George M. Pullman at "Ca
Last Night—A Grand Displa
works—Thirty-Five Relatives
In the Festivities.

Castle Rest, the beautiful
home of Millionaire George M.
never looked more attractive
night when the great palace wa
propriately observed the eig
birthday of his mother, Mrs. E
moth "Castle Rest" was buil
man. A number of years ago
Pullman and presented to h
anniversary of the event has be
celebrated. Mr. Pullman the
eclipse all previous celebrations
who have been at work about t
during the past week, consu
arrangements for last night's af

A DAILY ST. LAWRENCE repo
another newspaper man arrived
tle Rest last night just be
pyrotechnical display began. Th
was alive with activity, as th
Pullman family consisting of
and daughters of Grandma
Rev. Royal Henry Pullman,
Rev. James M. Pullman, Lynn
Albert B. Pullman, Charles L. P

This is the cover of the August 15, 1891 issue of *On the St. Lawrence* published daily in Clayton, New York, during the late 1800s. The offices of the newspaper were located downtown on the south side of Riverside Drive. The very first newspaper in Clayton was the *Clayton Independent*. It was first published in 1873, during the same year the railroad from Theresa to Clayton was completed.

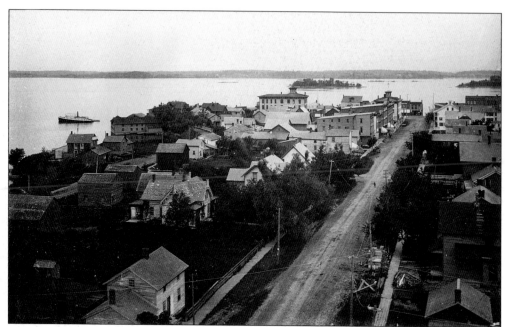

This panoramic view was taken from atop St. Mary's Catholic Church on James Street. Visible in the distance is Grindstone Island, with Governors Island (left) and Calumet Island (right) visible in the river foreground.

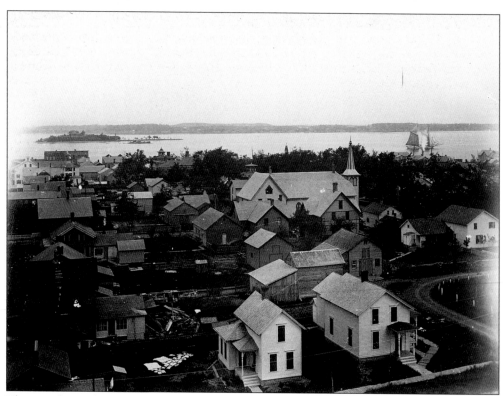

This aerial view, looking across the village, was shot from the bell tower on St. Mary's Church.

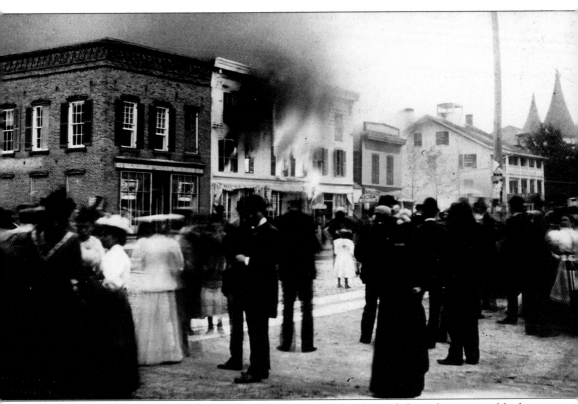

In July of 1895, fire starting in the Hubbard House outbuilding burned through an entire block downtown, leaving only the four corner buildings—the Hubbard Annex, the Heldt Block (corner of Water and James Streets), the Johnston House, and the Barker House (current location of the U.S. Post Office).

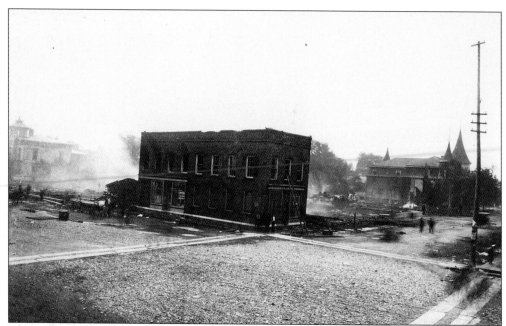

After the 1895 fire, there were complaints that because there were no hydrants, it had taken firefighters too long to lay hose and get water on the fire. Water was pumped from the river by steam fire engines, which limited pressure only to the strength of the hose. Although this method saved the village by preventing a much larger fire, hydrants appeared when the village water system was completed in 1902.

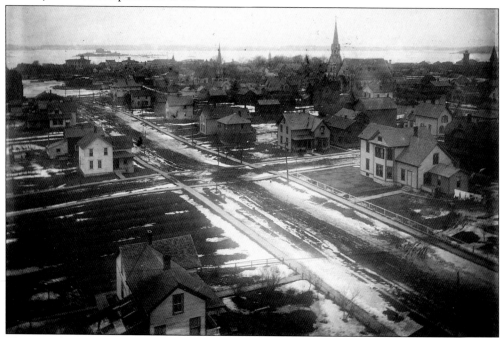

This aerial view of the intersection of Alexandria Street (looking down Alexandria Street toward the St. Lawrence River) was taken in the late 1800s. The street was originally named Alexander Street and was later changed to Alexandria.

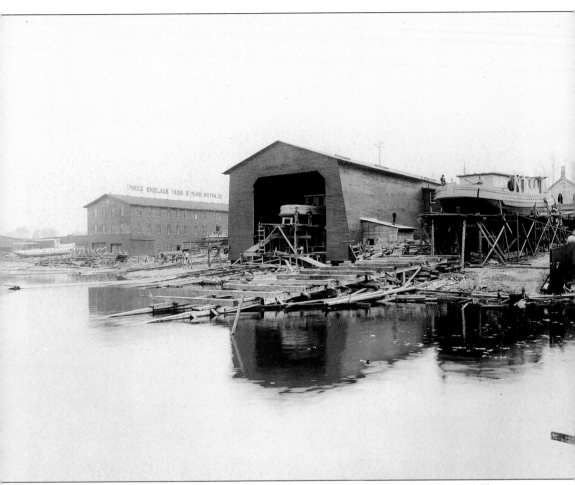

In the years before and during World War I, six sub-chasers were built in the village of Clayton. L.E. Fry & Co. built the first four sub-chasers, numbered 147, 148, 337, and 338. The Clayton Ship & Boat Building Corporation built the last two sub-chasers, numbered 411 and 412.

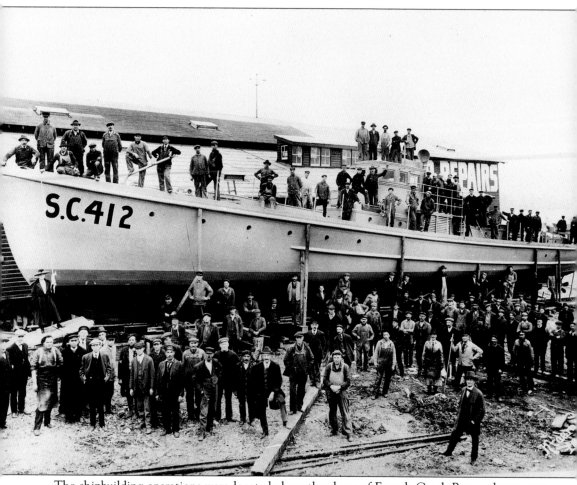

The shipbuilding operations were located along the shore of French Creek Bay at the current site of French Bay Marina and Remar's. Pictured here are Clayton Ship & Boat Building Corporation employees alongside subchaser #412.

Two

BUSINESS AND THE DOWNTOWN DISTRICT

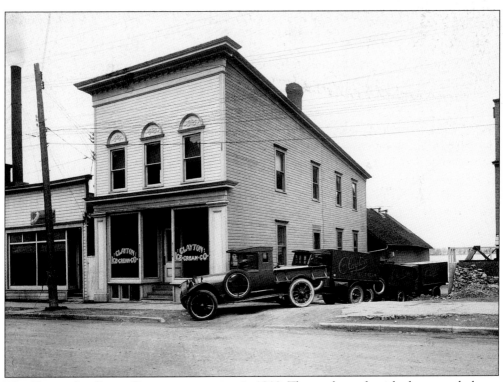

The Clayton Ice Cream Co. was in operation in 1918. The truck was furnished as an ambulance during the flu epidemic. Managers at different times were Tommy McCue and Ray Gillick. This location on Riverside Drive later housed offices for the Consaul Hall fueling operation. The Ice Cream Co. moved to Mary Street and later to Watertown.

In 1920, Carl H. Frink was faced with a bet that would ultimately lead to an innovation in snow removal. Fred Dailey, a bus line operator in Watertown, dared Frink to find a better way to clear the roads for his line. Frink's idea of mounting a metal plate to an automobile won him the bet and sparked the beginning of a new industry. Pictured is the "Frink Sno-Plows" facility on Webb Street in 1950.

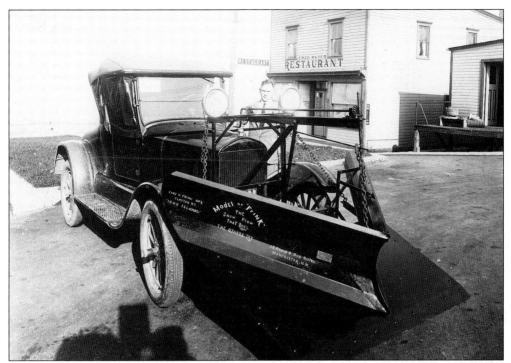

Pictured here is an early model of the Frink Snow Plow. Frink's plows are now known throughout the world. The restaurant in the background is the Edgewater Restaurant. The Edgewater was run by John LeTarte.

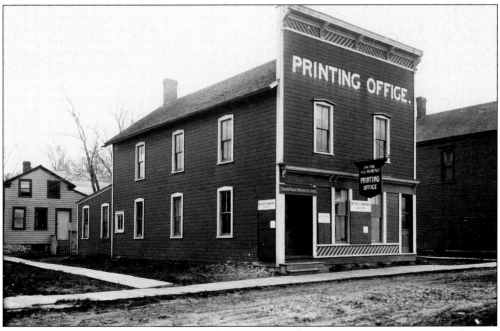

This is the printing office pictured in the late 1800s. *On the St. Lawrence* was printed in Clayton, New York, from this office on Water Street.

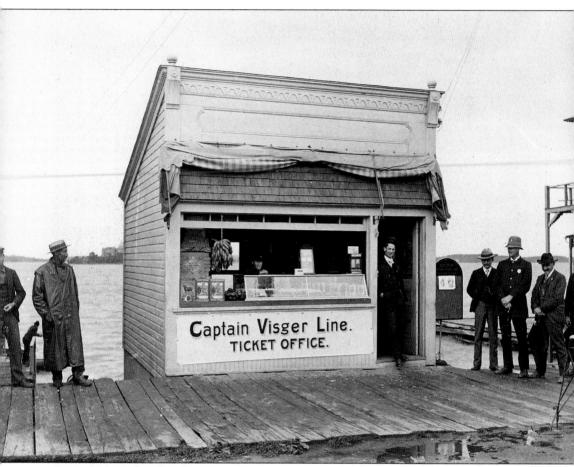

E.W. Corbin's first business was this tiny "Peanut Stand" and confectionery store, which served as a ticket booth for the Visger Line around 1905. Mr. Corbin was photographed by his brother H.J. Corbin. Pictured from left to right are as follows: Gene Russell, Alphonse Penet, Harry Marshall, E.W. Corbin, Lonny Hose, Constable Jay Alexander, Charles Thompson, and Jim Bowman.

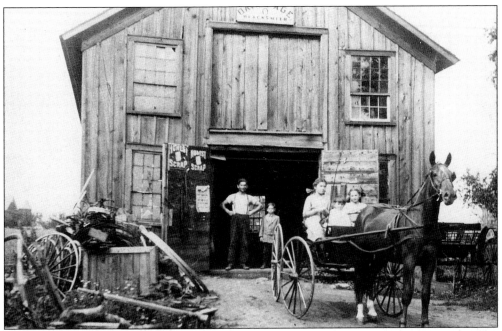

David Page's blacksmith business was situated on James Street. He is said to have made bobsled runners for Harry Cornell. Among other blacksmiths was Frank Potter, who operated on the corner of James and State Streets.

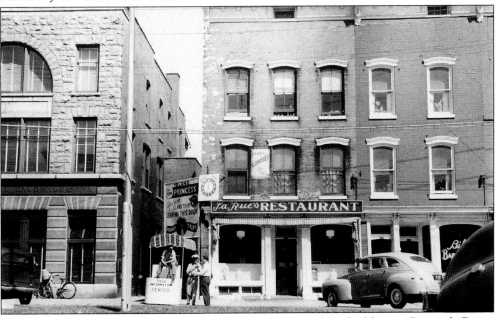

In 1947, Les Corbin, a local photographer, bought this waterfront building on Riverside Drive. The building became known as the Corbin Block shortly after this photograph was taken (historically it is known as the Barker Block). LaRue's Restaurant (shown in picture) operated for two years after Jim Jones closed the previous business in the building, The Candyland. Corbin's has been in this location for 50 years. This building, the oldest waterfront building in Clayton, was built in 1854.

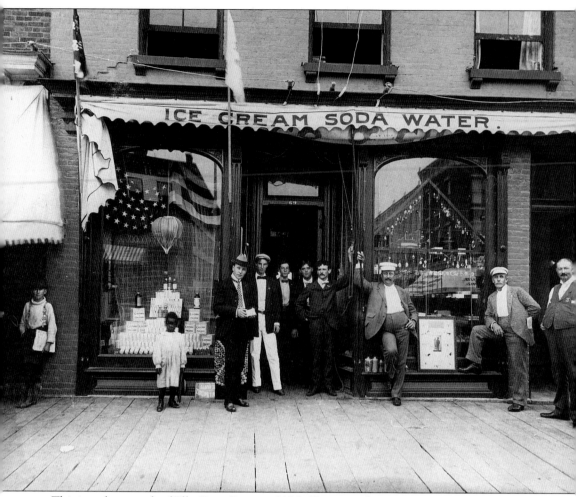

This is a photograph of Ellis Drug Store in 1895. Shown in this image are Fred Cerow, Bobbie, boy in May Irwin's show, Roland Carter, opera singer in May Irwin's New York show, Walter Irwin, Lawrence Ellis, Thomas Rees, Roy Riley, Al Garrett, G.M. Skinner, and Charles A. Ellis.

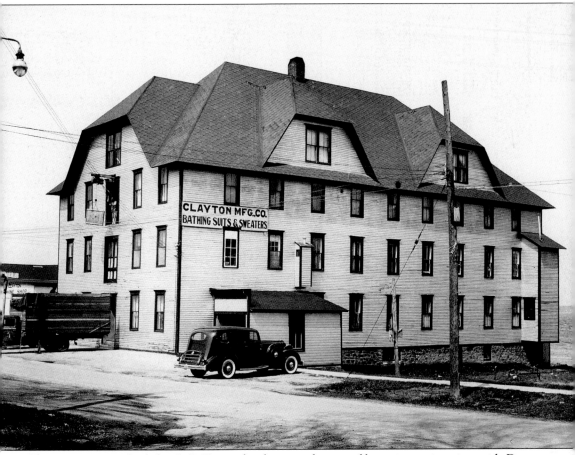

This structure was built by C.G. Emery for the manufacture of boats in conjunction with Dr. Bain. Known as the St. Lawrence River Skiff, Canoe, and Steam Launch Co., it operated only a short time here, moving to Ogdensburg, New York in 1895. For a time, the firm of Fry, Denny, and Mercier used the building for boat building. By the 1920s, George W. Hawn purchased it from the Emery estate and began a garment business. At peak operating capacity, the mill employed 145 people, making a variety of sweaters, swimsuits, and underwear. The Johnstown Knitting Mill ran the factory from 1950 until it was demolished in 1967. The building was located on what is now property of the Antique Boat Museum on Mary Street.

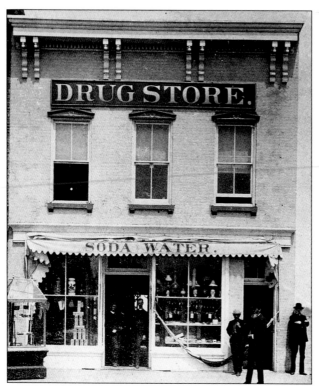

The Ellis Block was where the Ellis grocery and drug business operated in Clayton for well over 100 years, from the 1830s until 1958. Dr. Amos Ellis, who came to Clayton in the 1830s, was the founder of the business. The business passed through three generations of ownership before closing for good in 1958.

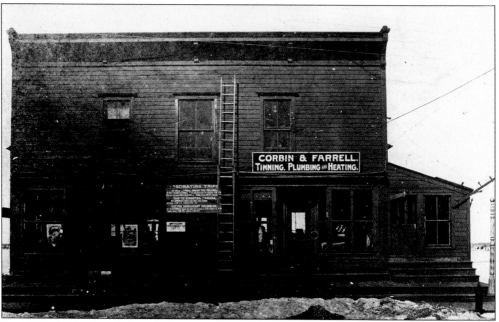

By 1908, the Corbin & Farrell business, operating in the Rees Warehouse Building on Water Street, had become Farrell and Whitney. By 1950, it was advertising as Farrell and Cain. Later, after a change of location, the business continued as M.E. Farrell and Son, with son Francis, and son-in-law Donald Turcotte. Betty Farrell Turcotte kept the books for the company. The business closed in 1985. Hilda's Place operates in that second location now.

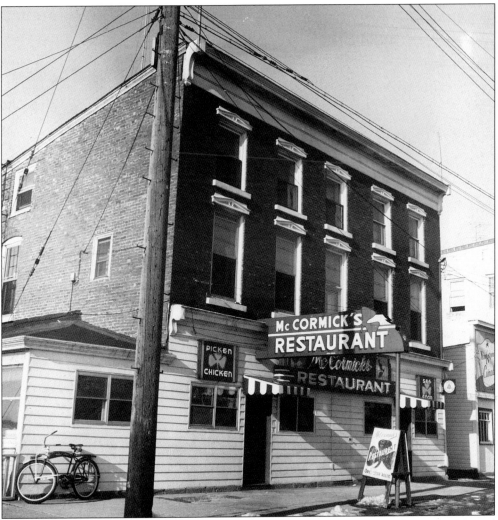

In 1945, Vincent Dee bought the Thousand Island Restaurant. It had been operated by Ed Rabideau for 12 years before his death. As McCormick's, it was enlarged and remodeled and became a popular spot for dining and banquets for nearly 40 years. A fire destroyed it in 1983, and it was not rebuilt.

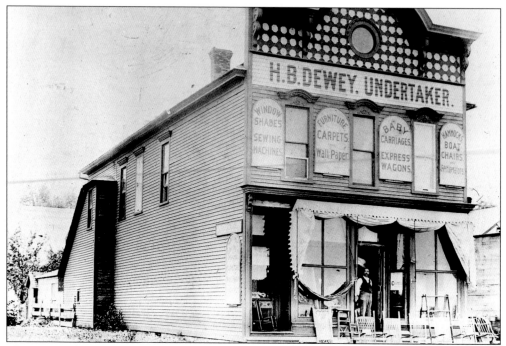

This is an early view of the H.B. Dewey Store on Water Street. As shown in the picture, Dewey sold a variety of goods and services, including furniture. At the time, Dewey operated in what is now a portion of Reinman's Department Store. The exact date is unknown, but is prior to 1908 as indicated by an ad in the 1908 Clayton Business Directory. The ad indicates that Dewey had since moved his operation to the Opera House block. By 1915, Dewey was advertising only the furniture business within the Opera House.

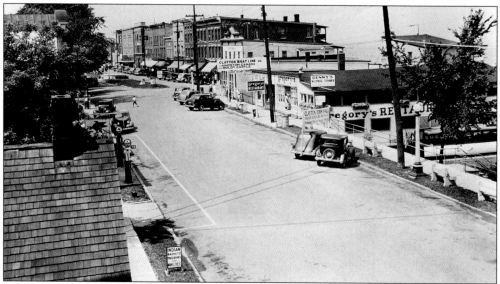

The Clayton waterfront is pictured here between Merrick and John Streets c. 1930. Gregory's Restaurant was in operation previous to 1930, under management of Gregory Brown. Harold Kendall and Jerry Fitzgerald solicited for the Clayton Boat Line in 1931 and 1932. The Denny Boat Line, also in the photograph, operated from this location for many years.

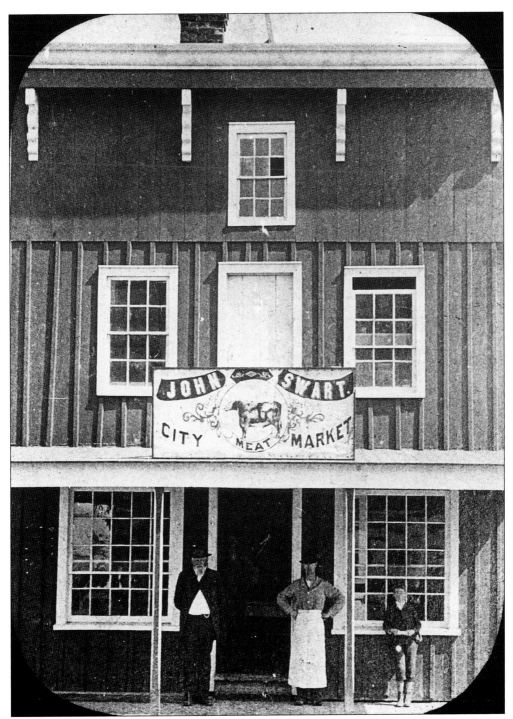

John Swart's Meat Market was on the south side of Water Street in the James to John Streets section. This (pictured) original market burned in the big 1895 fire, and was later rebuilt on the same location. The Eagle Shoppe now operates on the location where Swart's building once stood.

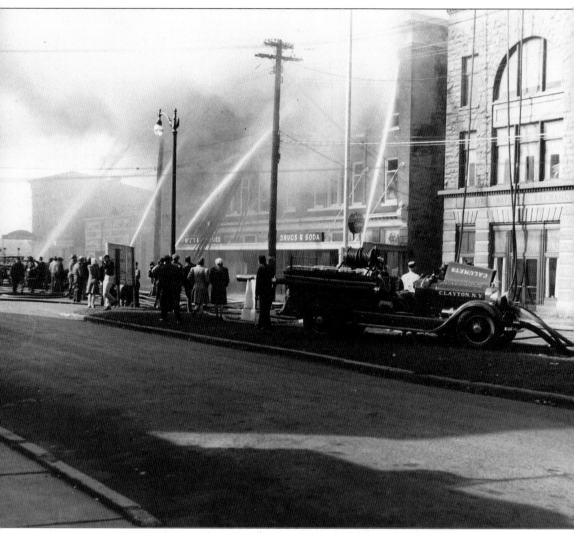

Ten apartments were destroyed in the Ellis Block fire on October 31, 1944. The fire originated at the rear of the building. Also badly damaged was the Waldron building next door. The Waldrons lost everything in their third floor apartment, and on the second floor, Dr. Fowkes's lab equipment was completely destroyed. The Clayton Volunteer Fire Dept. responded with their now, antique pumper truck. Both buildings were repaired only to be struck by fire again in 1988.

Pictured here is a map of the village that appeared in the *Patron's Pocket Business Directory of Clayton Village, New York*, compiled by Hamilton Child in 1908. Note the advertisements surrounding the map.

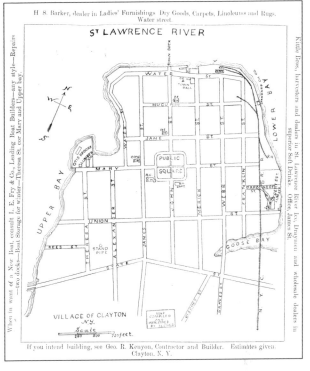

The Clayton Town Hall was built in 1903, and shortly afterward a four-sided clock that struck every half-hour was donated by the H.B. Dewey family and installed in the tower on top of the building. During the WW II years, patriotism dictated the installation of an airplane spotters' observation tower. The clock was therefore removed, to be stored until after the war. By wars end, someone in another patriotic gesture had contributed his gears and other parts to the scrap drive. About the time the museum was founded, the town hall was refurbished, the observation tower re-enclosed, and the muskie weather vane was given a new home atop the tower. The work of placing it in a position was done by Churchills of Clayton.

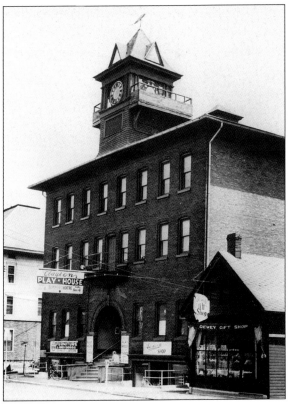

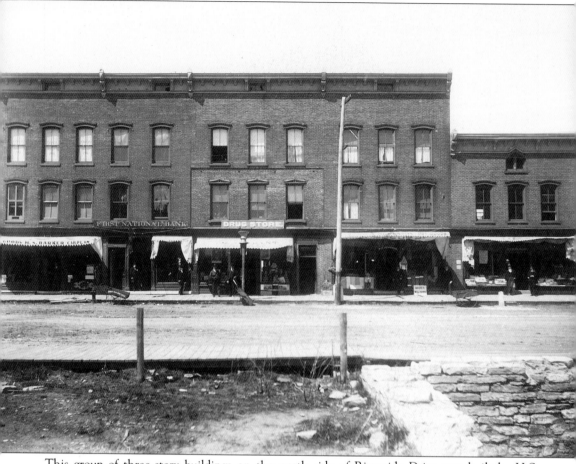

This group of three-story buildings on the north side of Riverside Drive was built by H.S. Barker. Housed from left to right are as follows: H.S. Barker's, First National Bank, Jos. Brabant's drugstore, and S.H. Johnson's. E.A. Burlingame was in business in the two-story building next door. This block contains the oldest waterfront buildings still standing in Clayton.

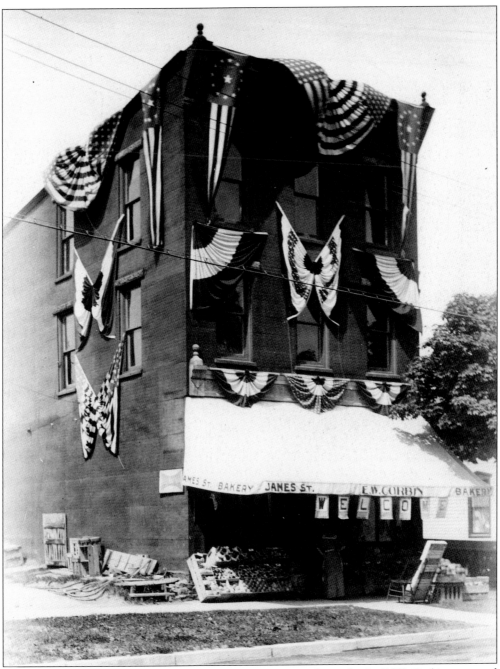

During WW I and while the highway to Watertown was being built, E.W. Corbin operated his own bakery, supplying bread to the work crews. This was gradually enlarged to a grocery business. Ernest Corbin went on to operate a general store on the corner of Riverside Drive and James Street for over 25 years.

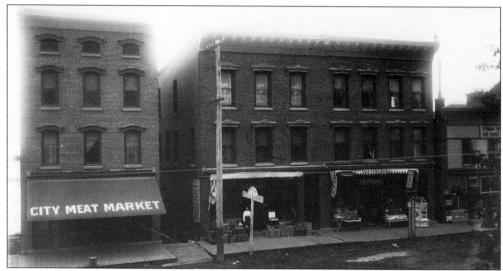

The City Meat Market was located on Riverside Drive, next to the Willams Block. Charles Cerow purchased the land from A.F. Barker in 1898 and completed the building by 1899. In 1921, his son, Gordon Sr., joined him, and the business continued until 1972.

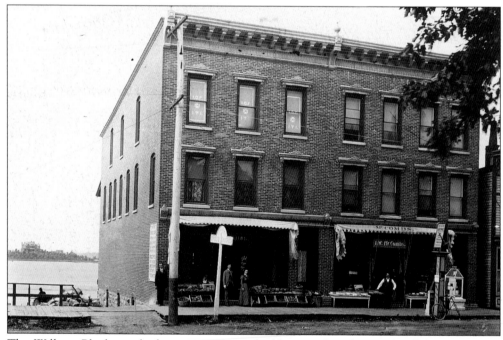

The Willams Block was built as two separate buildings with a fireproof wall between. A.L. Willams's side was built for occupancy in 1895. Willams and his wife ran a drug and grocery business. Henry Barker built the adjoining block in 1897, where J.W. McCombs was in business. Willams bought out the Barker half in 1905 and sold it in 1946 after which the building housed numerous businesses. Among these were the Grand Union, American Stores, and Helene's Studio and Gift Shop. Presently, the Clayton Chamber of Commerce and the Riverside Cafe are located in the Willams Block. The Cerow Building was built in the vacant lot to the left. In this photograph you can see the castle on Calumet Island in the background.

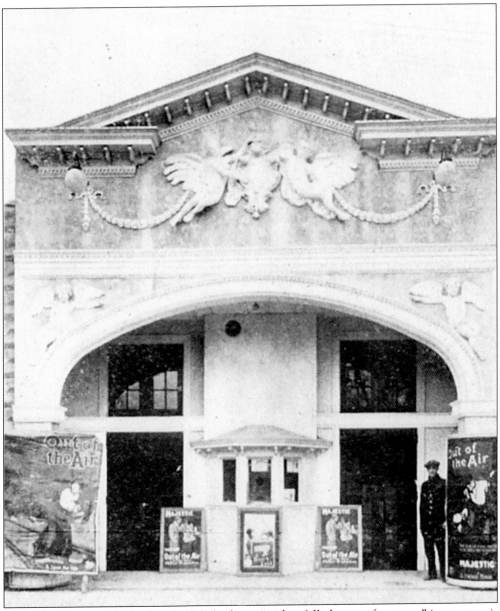

The Lyric Theater, 1915, advertised daily shows "with a full change of program" in a souvenir program, dated June 1-3, 1915, from the Eighteenth Annual Fireman's Convention in Clayton. The theater operated on James Street in the location of the current Brandywine Shoppe.

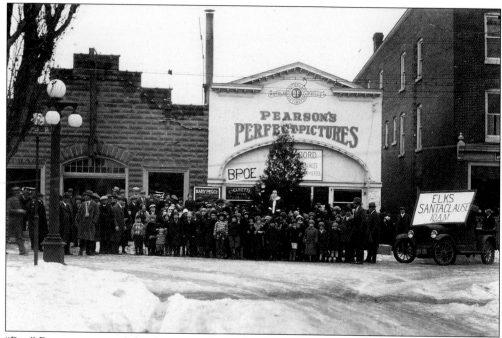

"Pop" Pearson operated the theater on James Street in the 1930s. At Christmas time Pearson's Perfect Pictures gave free passes to children, photographed here for the occasion.

Wm. H. Thorpe operated a jewelry shop from this location on James Street in the late 1800s. Currently, the Winged Bull Studio is housed in this building.

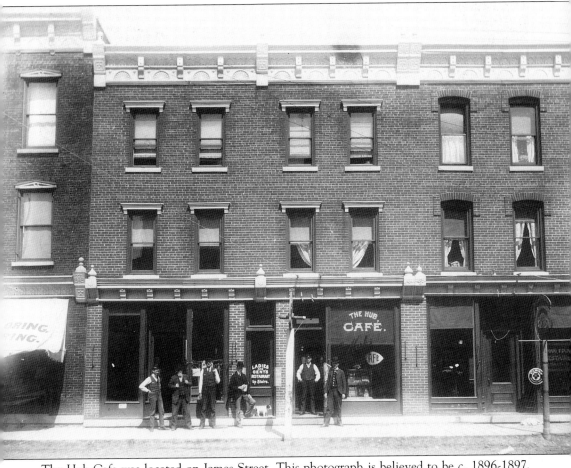

The Hub Cafe was located on James Street. This photograph is believed to be *c.* 1896-1897, taken soon after construction was completed after the great 1895 fire. This business operated in the Grapotte Block. Next door (right) was the Thousand Island Restaurant. Mr. Grapotte operated the Hub Cafe as a lunchroom and cigar stand for gentlemen. Upstairs was a ladies lunchroom and ice cream parlor.

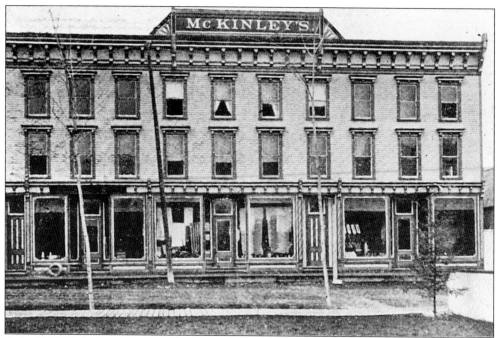

G.H. McKinley sold "fancy and staple groceries, dress goods, notions, hosiery, carpets, boots & shoes" out of his store in The McKinley Block in the late 1800s.

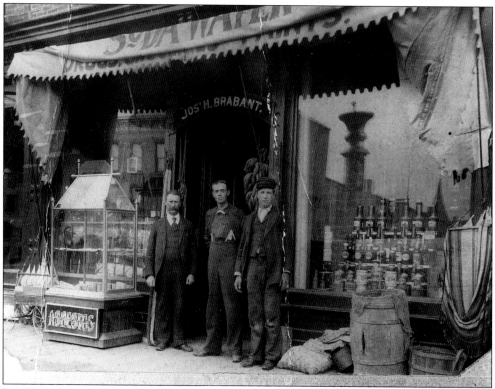

Jos. H. Brabant Drug Store in the 1800s was located on Water Street in the Barker Block.

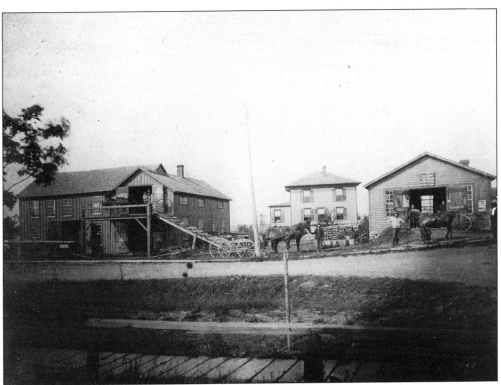

This is an image of the corner of Upper James and State Streets; Thibault's Blacksmith shop is on the right, and the feed mill, which later became Crandalls, is to the left.

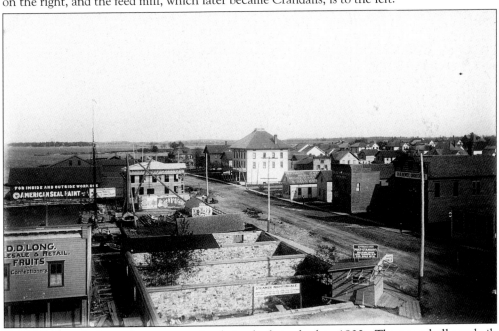

This photograph shows the pump station being built in the late 1800s. The town hall was built later in 1904. On the south side of Water Street are the Herald House, the old Thorpe Jewelry Store, the Bush basket shop, the *On the St. Lawrence* printing shop, and Dewey's furniture store.

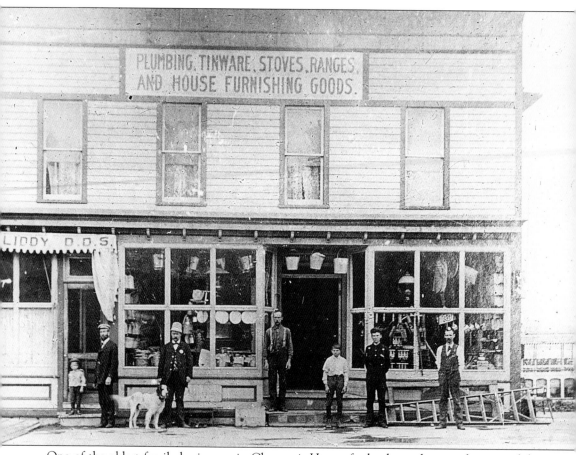

One of the oldest family businesses in Clayton is Hungerfords, shown here at the turn of the century on Water Street.

Three

VILLAGE HOTELS

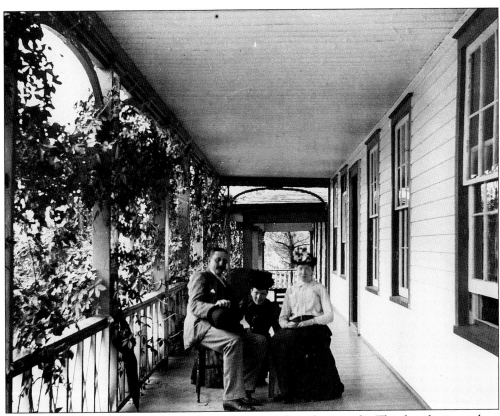

Guests sit on the porch of the Walton House in this photograph. This hotel, situated on the corner of James and Water Streets, had three stories, 200 feet of verandah, and could accommodate 150 guests. Stephen Decatur Johnson combined the original Northern Hotel with the Issak Walton House and operated the hotel as the Walton House.

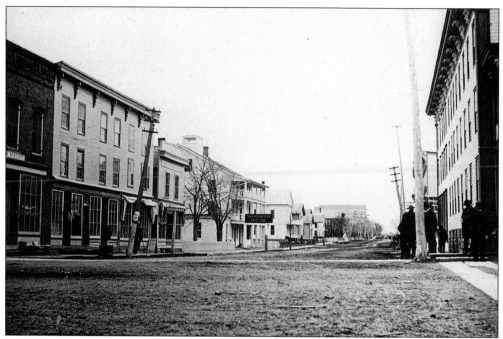

This is an early view looking south on James Street from Water Street. On the right is the Walton House and in the center of this photograph, on the left side of James Street, is the original Hubbard House. Much of the early hotel business focused around the transient business brought in by timber and shipbuilding workers. As the 1800s progressed, the larger hotels began to accommodate more summer tourist traffic.

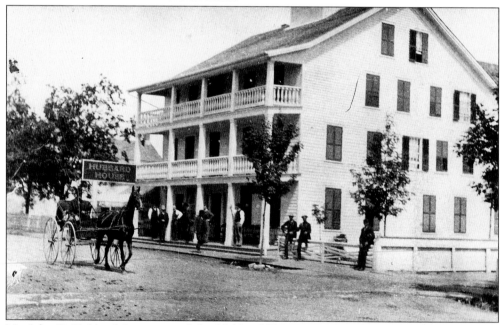

Mr. John B. Hubbard first operated the Hubbard House in 1850, when it was acquired. Prior to that time it had been Moffatt's Inn. After the 1895 fire, the Hubbard House was rebuilt out of brick.

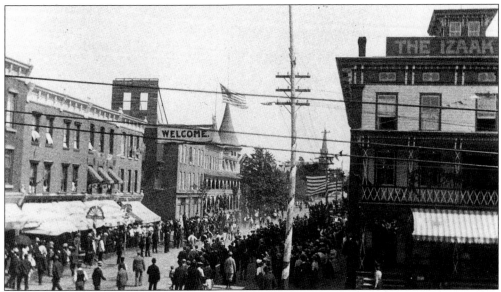

This photograph shows the Hubbard House and annex (center) as it looked after the rebuilding from the 1895 fire. The Heldt block (far left) added a third story, and the blocks adjacent to it on James Street were rebuilt in brick. The Issak Walton House (right) later became the Walton House.

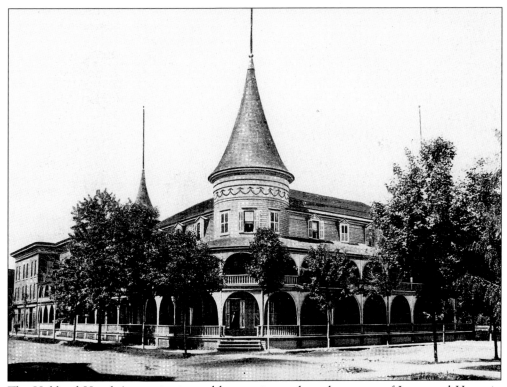

The Hubbard Hotel Annex is pictured here as it stood on the corner of James and Hugunin Streets.

The brick Hubbard House is shown here after the annex fire in 1909.

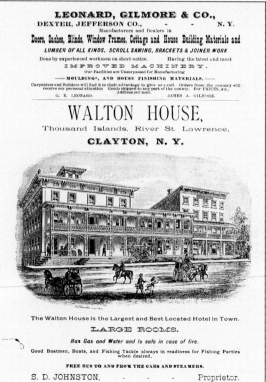

This is an advertisement for the Walton House. The porches of the Walton House faced the river giving its visitors a magnificent view. As tourism increased in the latter part of the 1800s so did the popularity of these grand hotels.

50

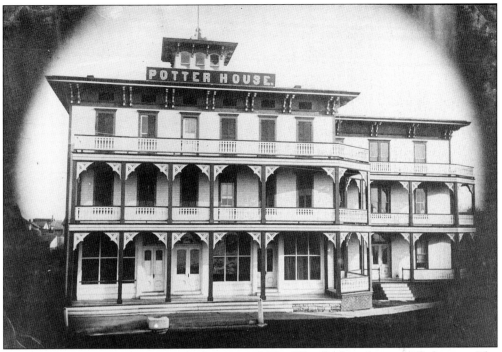

In Clayton, the Potter House was built, renamed The West End, and eventually became The New Windsor. This name lasted until the structure burned in 1906.

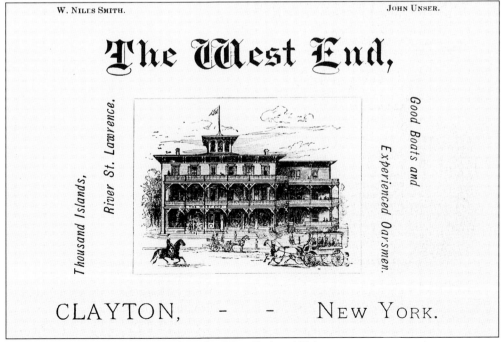

The New Windsor was advertised as The West End in 1884.

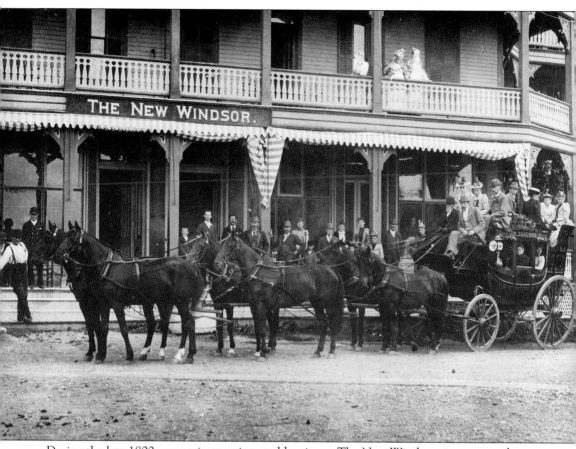

During the late 1800s, excursion parties would arrive at The New Windsor via stagecoach.

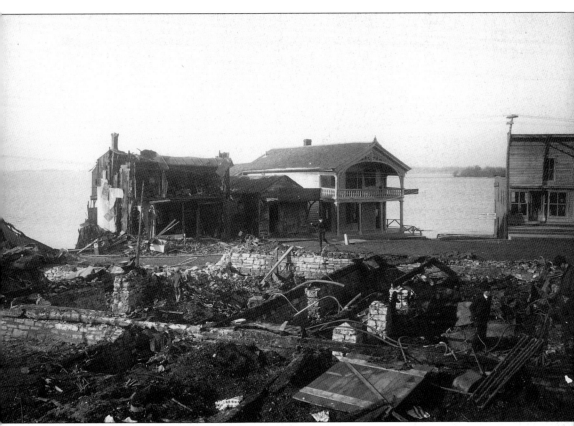

These are the ruins from the 1906 New Windsor Fire.

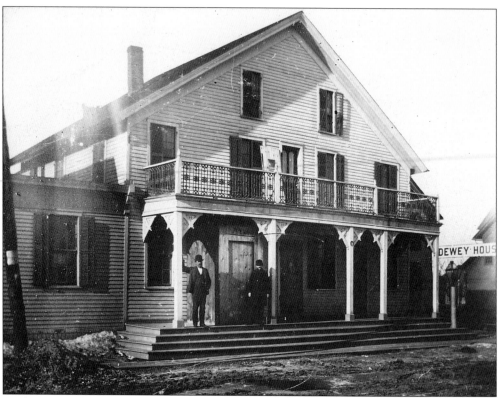

At the east end of downtown, close to the railroad terminal, were three hotels: the Pastime, the Herald House, and the Dewey House (pictured).

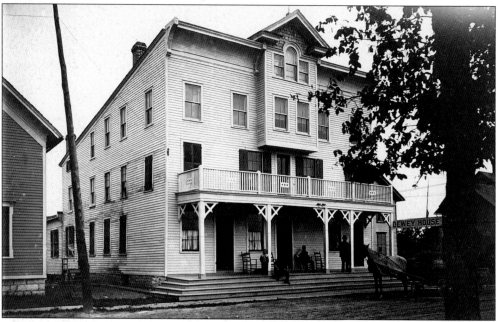

The Dewey House, owned and operated by Benjamin Dewey, became the Clayton Hotel and eventually O'Brien's Hotel. Today, O'Brien's Night Club and Restaurant sits in its location.

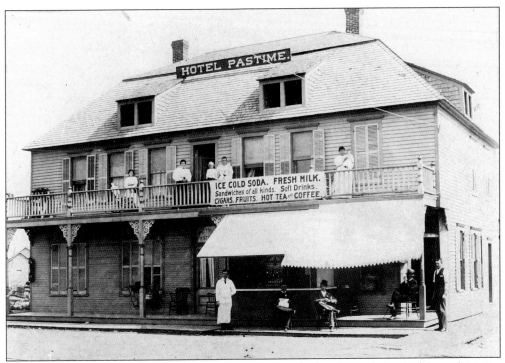

The Hotel Pastime stood on the current "Frink" site. The hotel stood close to the rail station and the river. Eventually it was renamed the Riverview Hotel. This picture is believed to be dated 1888.

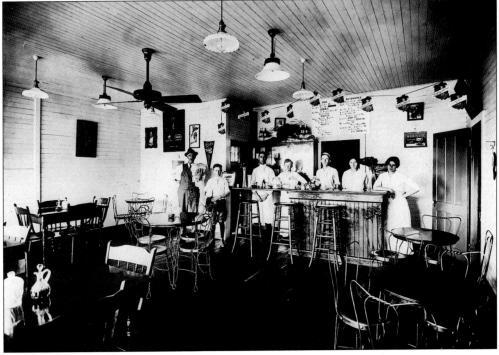

Pictured here is the Hotel Pastime's lunchroom.

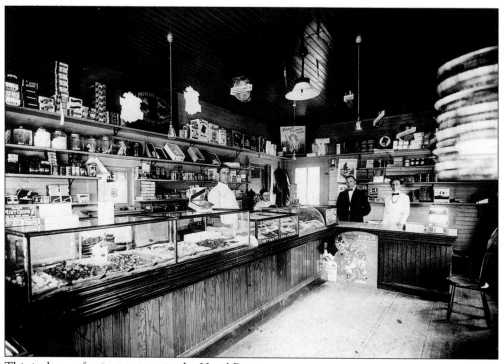

This is the confectionery store in the Hotel Pastime.

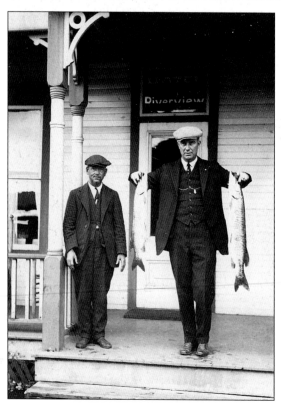

Proud fishermen pose on the porch of
the Hotel Riverview.

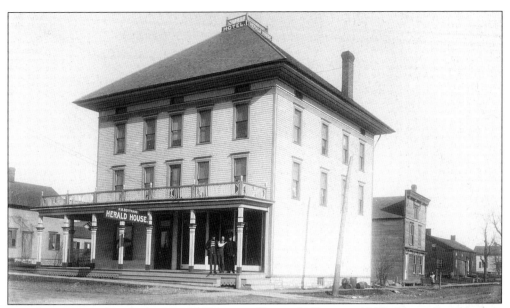

Napoleon Bertrand built the Herald House on Riverside Drive in 1898. Originally, it had six rooms. Eight more rooms were added in 1908.

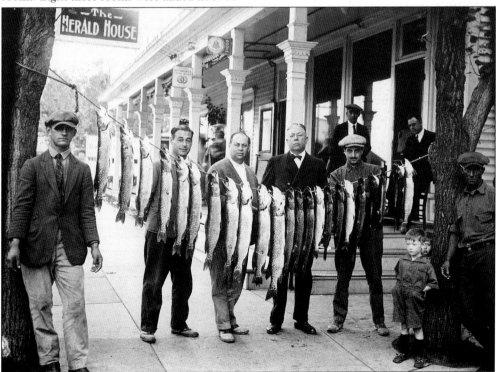

Guests of the Herald House display the days catch. The Herald House is today's Thousand Island Inn. The Herald House is given credit as the birthplace of Thousand Island dressing. Sophia LaLonde, of Clayton, invented the dressing and gave the recipe to Ella Bertrand, then owner of the Herald House. The dressing was served in the restaurant and quickly became a favorite of the rich and famous visiting the Thousand Islands on vacation.

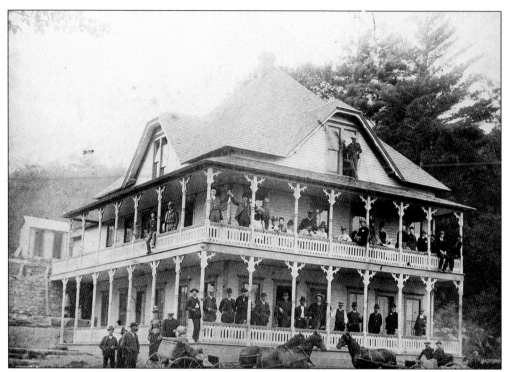

The Hotel at Frontenac Crystal Springs was built in 1890 by Malcom B. Hill. Charles Emery owned the hotel and springs in 1904 and sold water to the islanders. The Frontenac Crystal Springs Co. was started in 1921 and was operated by the Tifft family for many years. Today, the business is still in operation on Crystal Springs Road outside of the village.

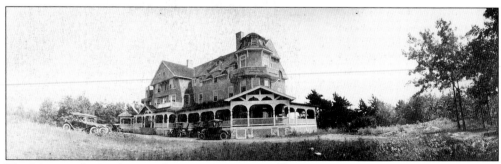

The Manatauck Hotel on Bartlett Point was serviced by a bus that met all trains in Clayton. A boat, *The Brownie*, also transported guests for the short trip across French Bay.

Four

SUMMERS OF TOURISM

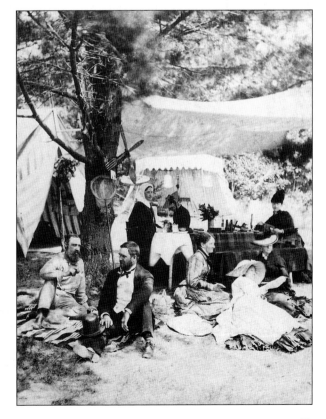

In August 1872, Pres. Ulysses S. Grant visited the Thousand Islands region as a guest of George Pullman, of Pullman sleeping car fame. President Grant's visit brought nationwide attention to the area and acted as a catalyst in turning this region into a major resort destination. Pictured is President Grant, second from the left, and General Philip Sheridan, left, enjoying a picnic outing in the Thousand Islands.

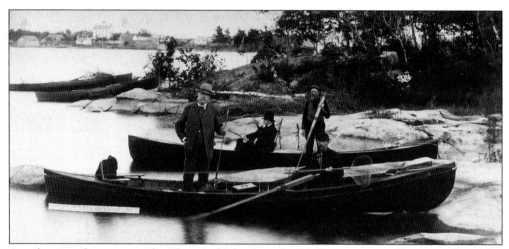

Another president to visit the Thousand Islands in the 19th century was Chester Arthur. This photograph, taken on September 30,1882, shows President Arthur (left) accompanied by R.G. Dunn and the St. Lawrence River guides, Wheeler and Comstock.

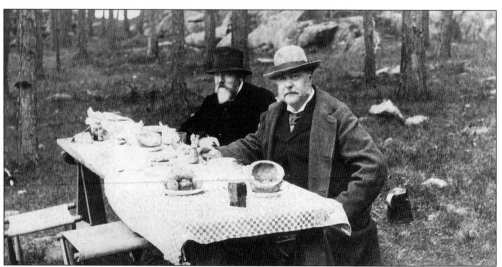

President Arthur and R.G. Dunn are pictured here at a picnic outing in the Thousand Islands. The date of this photograph is believed to be 1882.

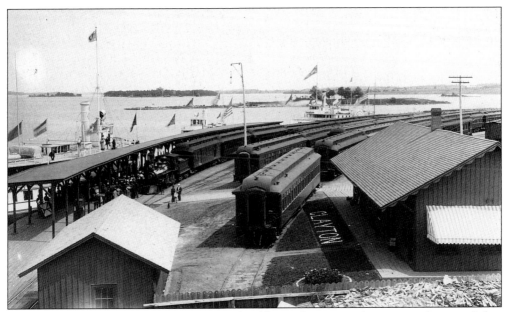

Railroads were built through promotion and publicity. Consequently, it was only natural that their business would be built the same way. Two years after the track was finished as far north as Clayton, the wonders of this area were being advertised in McIntyre's photographs at the 1875 centennial in Philadelphia.

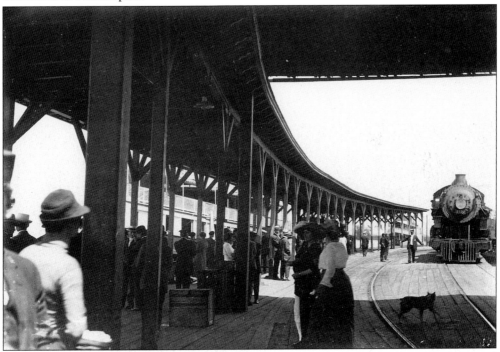

Overnight trips were available to and from all points. As many as 16 trains arrived or departed daily from the Clayton terminal; this in itself was unique. A passenger could practically step from the train and onto the deck of a boat, as one of the four tracks came within about 20 feet of the river.

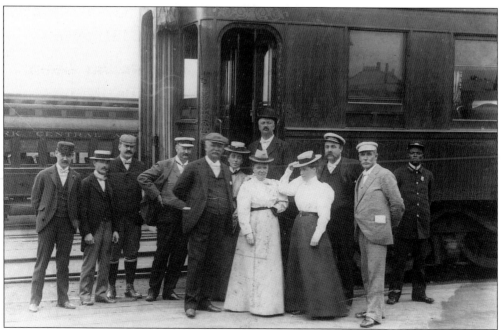

Nationwide attention brought visits from some famous people. Here, May Irwin poses with friends at the Clayton Depot. She summered on Club Island near the head of Grindstone Island in the 1890s, and later had a farm near Spicer Bay. She often performed downtown at the Clayton Opera House.

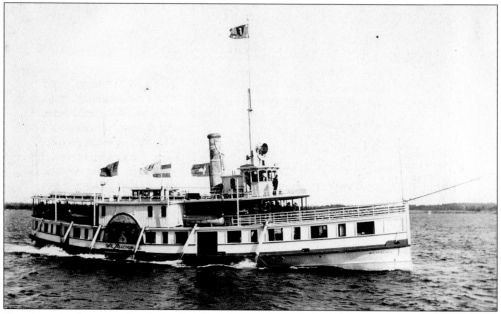

Continuous advertising by the railroad necessitated an ever increasing number of hotels, most of which were built on the islands or near Alexandria Bay, which lacked a railroad. To remedy the water transportation situation, the Folgers built and maintained the White Squadron; a fleet of immaculate boats run in conjunction with the railroads. The pride of the fleet was the *St. Lawrence* with its huge searchlight and its New York Central Railroad shield.

These are two railroad poster photographs. The *New Island Wanderer* was built in 1887 and captained by Walter Visger for a year. Next in charge was Capt. Chester Rees who ran the boat until 1891 when he resigned to take over the *STR St. Lawrence*. At this time, Capt. Eli Kendall became the captain of the *New Island Wanderer*. The two large steamers were in competition for their search light tours. In 1893, this ship is quoted as carrying 20,000 people annually to view the charming scenery of the islands.

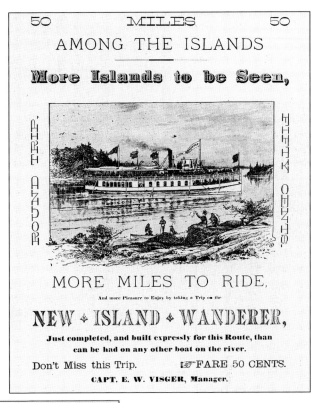

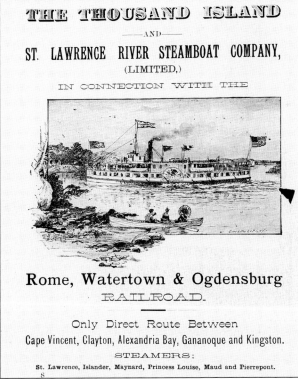

This advertisement is from an 1890s railroad book, which tells the story of the early steamship and railroad connection. The *STR St. Lawrence*, pictured here, was famous for searchlight excursions among the islands. The *STR St. Lawrence* was launched from Clayton in May 1884, and was used as a tour boat until 1926. As one of the vessels of the White Squadron fleet, the *St. Lawrence* carried 650 passengers and was reputed to be the most popular of the excursion boats. The artist Al Keech painted the ship's paddle boxes. The *St. Lawrence*, captained by M.D. Estes before 1891, was then in the charge of Capt. Chet Rees for many years.

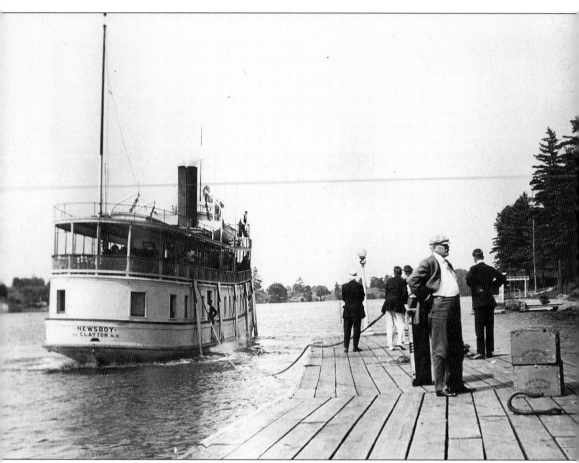

The *News Boy*, successor to the *Islander*, carried mail when the resorts between Clayton and Alexandria Bay had mail service four times a day. Built in Michigan in 1889, the *News Boy* ran from Clayton to Alexandria Bay from 1909, when the *Islander* burned at the Crossman dock, until 1912 when she burned at Clayton.

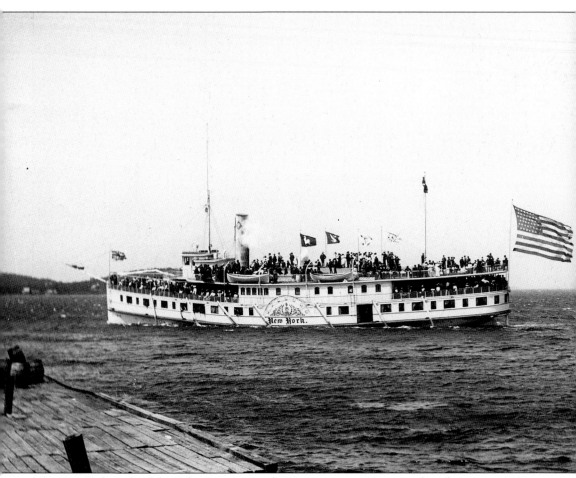

The *New York*, pride of the Folger Line, carried 750 passengers and operated on the river in 1898 alongside the *Empire State* and the *America*. She made daily runs from Kingston and Montreal, stopping at all Thousand Islands ports of call except Murray Hill and Grenell Island Parks. The *New York* was dismantled in 1908.

The steamer *St. Lawrence* delivers vacationers to Murray Isle Park at Murray Isle *c.* 1890-1900. In addition to delivering people from the railroad docks in Clayton, the steamer was known for its searchlight cruises.

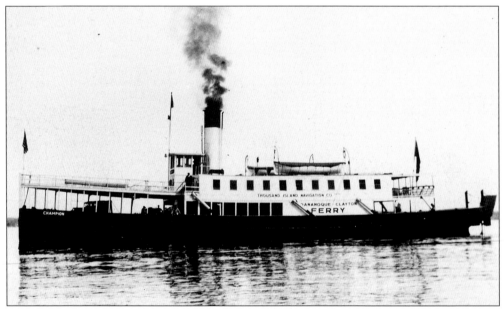

Built in Quebec in 1897, the auto ferry, *Champion*, with her sister ship, *Frontenac*, ran between Clayton and Ganonoque, Ontario. The steam whistle from the *STR St. Lawrence* was used as the whistle for the *Champion*. The ships ran from the early 1900s until 1938 when the T.I. Bridge was finished.

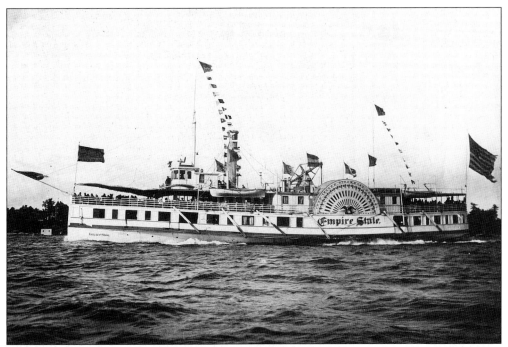

The *Empire State* was originally registered at Rochester under the name of *Sylvan Stream*. In 1893, the sidewheeler was transferred to Cape Vincent and renamed *Empire State*. The largest boat in the Folger Brothers White Squadron, it had a listed capacity of 1,000. This boat made connections for mail and passengers out of the rail station in Clayton.

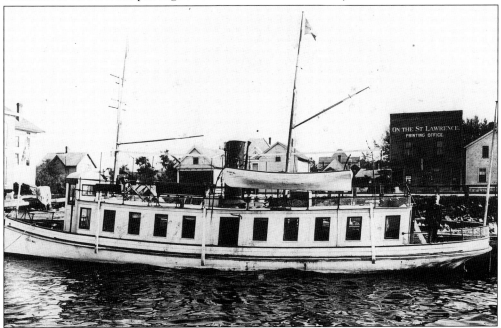

The *Little Mac* was built in Buffalo in 1886. This ferry boat ran passengers from Clayton to places such as Grand View Park, Thousand Island Park, Murray Isle, Grenell Island, and the Pullman house.

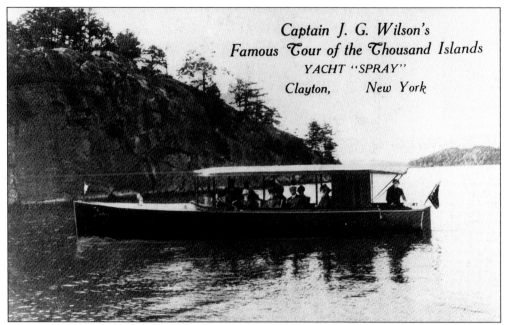

Capt. "Gord" Wilson is known as the first captain to maintain permanent regularly scheduled tours of the islands out of Clayton. Around 1913 he sold his old boat called the *Spray* and built a new 20-passenger boat, complete with comfortable wicker chairs. He kept the name *Spray* for his new boat, pictured here.

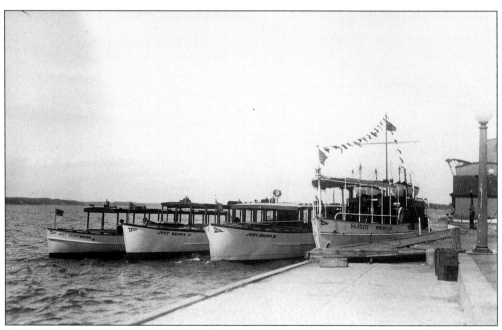

The Just Brown fleet operated out of Clayton. Pictured is the *Just Brown, Just Brown III, Just Brown IV,* and the *Dauntless,* which originally came from Association Island. Another in the fleet, the *Just Brown II,* is not pictured.

A new line of boats called The Independent Line was formed in the spring of 1935. The line consisted of *Spray VI* (Captain Cupernall), *Helen C* (Capt. Emmett Calhoun), *Julia III* (Capt. Fred Marshall), and the *Miss St. Lawrence* (Capt. Alex Wilson).

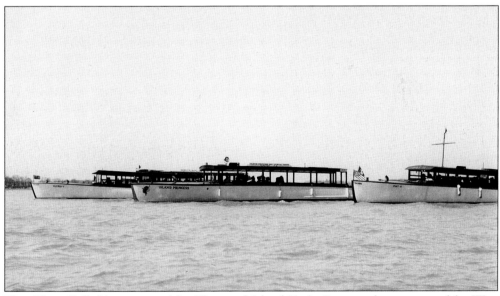

The *Gloria V* (left) was owned by Thousand Island Yacht Lines and was operated by Wm. Lantier. *The Island Princess* (center) was owned and captained by Lawrence Balcom. *Pat* was owned and captained by Ab Conant, and later by his sons Robert and Clifford.

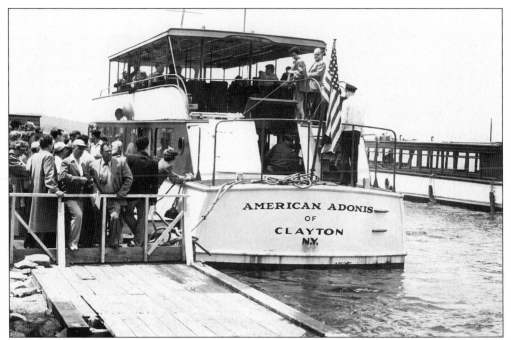

The *American Adonis*, captained by Robert Conant, loads passengers while a smaller tour boat waits for the overflow. The *Adonis* was the first of the double-decker boats. The double-decked fleet, owned by the American Boat Line, consisted of the *Adonis*, the *American Adonis II*, the *American Venus*, and the *American Neptune*.

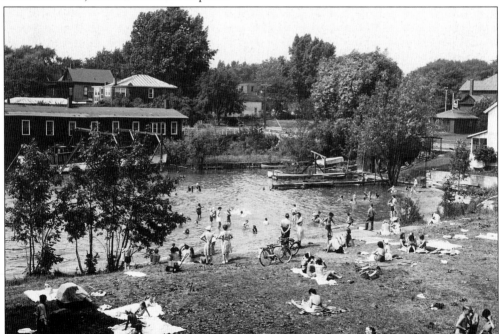

The Village of Clayton operated the Mary Street swimming beach area during the late 1940s until the early 1960s. Now this area is part of the Antique Boat Museum complex. The boat museum now holds its annual boat auction on this site each year.

The Antique Boat Museum on Mary Street draws thousands of visitors to Clayton every year. The boat museum, formerly known as The Shipyard Museum, is currently in its 34th year of existence.

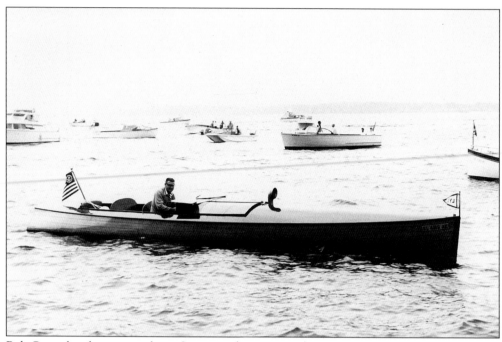

Bob Cox pilots his antique boat, *Suwanee*, during an early Antique Boat Show. This boat has since been donated to the museum.

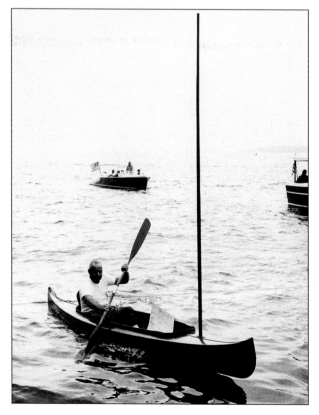

The Antique Boat Museum holds its annual Antique Boat Show during the first week in August each year. In the late 1960s, Glenn Wilder enjoyed participating in the Antique Boat Show Parade in *Grandpa's* skiff.

Five

IN THE ISLANDS

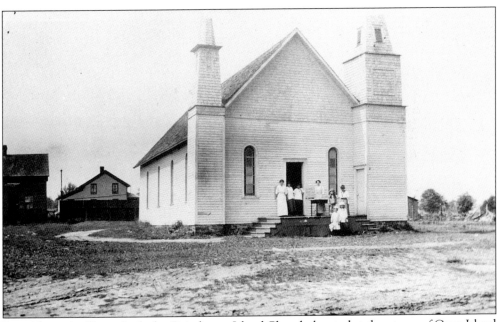

Rev. Alexander Shorts built the Grindstone Island Church, located at the corner of Cross Island Road and North Shore Road in Thurso Village, in 1890. Prior to that period, services were held in the schoolhouse. The church is now in its second century of operation on Grindstone Island.

To meet the needs of the family, community schools were opened on Grindstone Island. Pictured is the upper schoolhouse located on Cross Island Road. The upper schoolhouse was built in 1840. In 1880, a second school was built near the foot of the island.

The cheese factory operation on Grindstone Island was located on Base Line Road. The photograph shown was taken in the 1950s. Farming declined during the middle part of the century. The factory, operating long before electricity was brought to the island, could not compete as refrigeration standards and sanitary regulations were introduced.

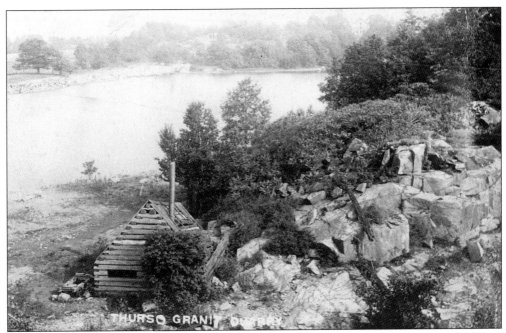

The Thurso granite quarry is pictured here. The village of Thurso on Grindstone Island was named after Thurso, Scotland. One of the earliest industries on the island, other than farming, was granite quarrying. Small quarry operations in one form or another ran from 1880 to 1908.

This is an image of the Grindstone Island mail run in 1946. Pictured from left to right are as follows: Paul Carnegie, Manley Rusho, Emmet Dodge, Jack Garnsey, Lawrence Garnsey, Bob Garnsey, Audrey Lashomb, and Emma Carnegie.

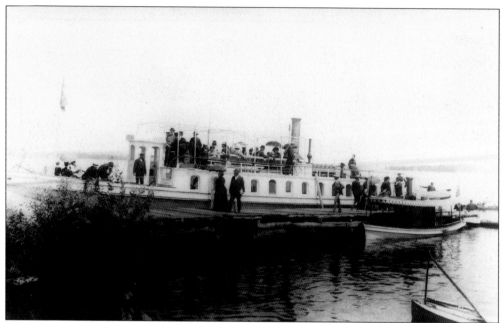

The steamer, *Magic,* is shown as it docks at the American Canoe Association camp located on Grindstone Island in 1885. Arrangements were made with the steamer to leave Clayton daily to take canoeists to the camp at 8:30 and 10:30 a.m. and 1:00, 3:00, and 6:30 p.m. The fare was 25¢ per person, canoes and outfits free.

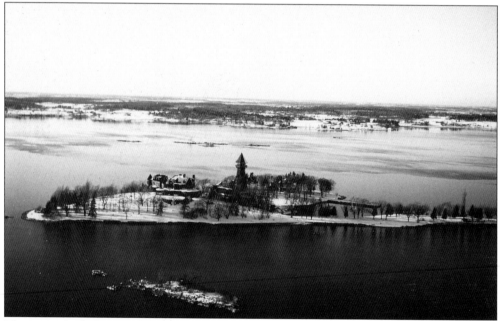

This is an aerial photograph of Calumet Island taken by Les Corbin. Grindstone Island is shown in the background. Calumet Island is clearly visible from, and directly opposite, the Clayton village waterfront. Charles Goodwin Emery purchased Calumet, originally named Powder Horn, from Thomas G. Alvord in 1882. Emery gave the island its new name, Calumet, meaning "Indian Pipe of Peace."

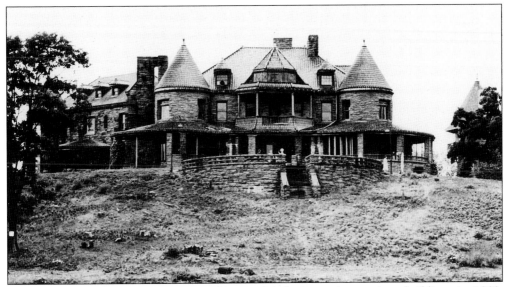

Emery originally began construction of a wooden home and several outbuildings in 1882. Construction of the large native granite castle did not begin until 1893. The original wooden structure was dismantled and moved to nearby Picton Island (also owned by Emery). Granite for the new home was quarried from nearby Picton and Grindstone Islands. Construction of the new home did not end until December of 1894, and further construction of a caretaker's home, powerhouse, electric plant, boathouses, seawall, and eventually the water tower would continue into the following century.

Quarrying granite was a major early industry in the Clayton area islands. In addition to the granite quarry on Grindstone Island, there was a quarry operation on the north side of Picton Island. Pictured here is the Picton Island operation in the early 1900s. Remains of the quarry are still clearly visible on the island today.

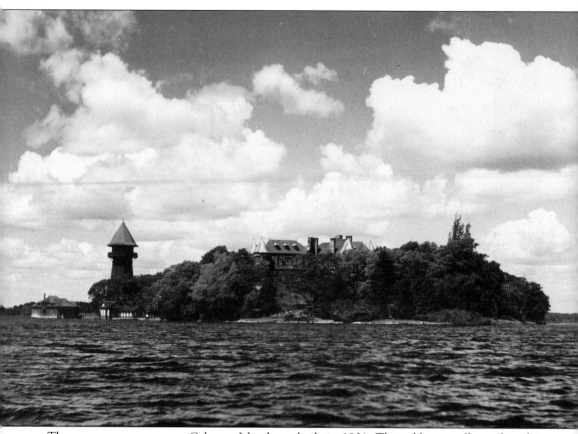

The stone water tower on Calumet Island was built in 1901. This addition still stands today and serves as a lighthouse and familiar beacon for all that reside in Clayton and boat in the nearby waters.

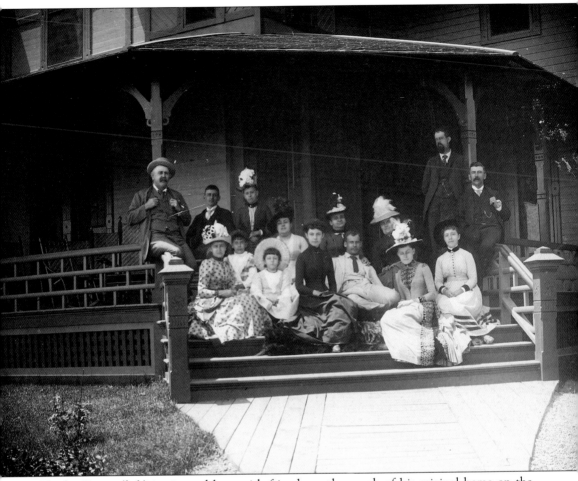

Charles Emery (left) is pictured here with friends on the porch of his original home on the island in 1883. Emery was the founder and owner of the Brooklyn-located tobacco firm of Goodwin and Company. Emery's tobacco company quickly became a close rival of W. Duke, Sons, & Company, managed by James Buchanan Duke. In 1890, the businessmen, along with three other top tobacco companies, formed the powerful American Tobacco Company. Charles Emery became the company's first treasurer.

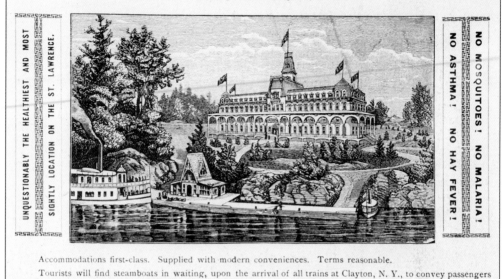

ROUND ISLAND HOUSE,

ROUND ISLAND, THOUSAND ISLANDS.

(First Landing below Clayton, N. Y.)

UNQUESTIONABLY THE HEALTHIEST AND MOST SIGHTLY LOCATION ON THE ST. LAWRENCE.

NO ASTHMA! NO HAY FEVER! NO MOSQUITOES! NO MALARIA!

Accommodations first-class. Supplied with modern conveniences. Terms reasonable.

Tourists will find steamboats in waiting, upon the arrival of all trains at Clayton, N. Y., to convey passengers to Round Island, one and one-half miles distant.

Here is an 1886 advertisement for the Round Island House located on Round Island, 1 mile down river from the village of Clayton. The Round Island Park Association was founded as a Baptist church resort in 1878. The Round Island House, built in 1881, was the centerpiece of the island. The hotel boasted first-class accommodations.

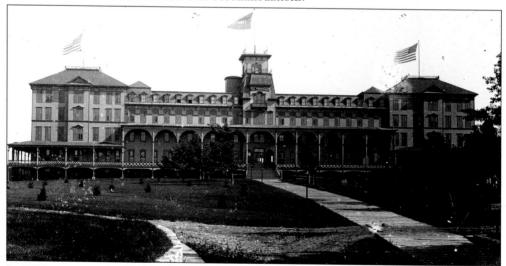

In 1888, wings were added to the original structure to expand its capacity. Then in 1889, the Round Island Park Association became non-sectarian, as the hotel changed ownership and was renamed the Frontenac (shown here). Charles Emery, of nearby Calumet Island, decided the hotel could be improved; this led to his purchase of the hotel in 1890. Emery hired New York architect J.W. Davidson to remodel the structure. Upon completion, the hotel re-opened as the New Frontenac.

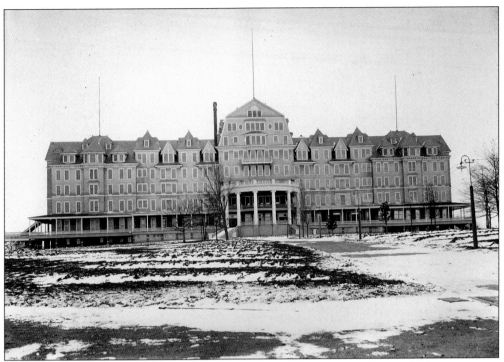

The newly remodeled New Frontenac is pictured here in winter. The hotel stood seven stories tall, with the center tower rising an additional two stories. The hotel held over four hundred rooms, each with its own electricity and bath. Local tour boats would pass close by the island so passengers could catch a glimpse of the life of luxury.

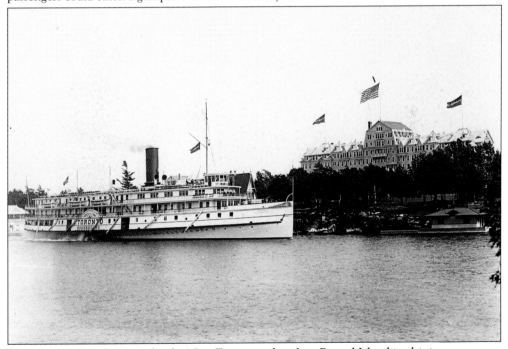

The steamer *Toronto* passes by the New Frontenac hotel on Round Island in this image.

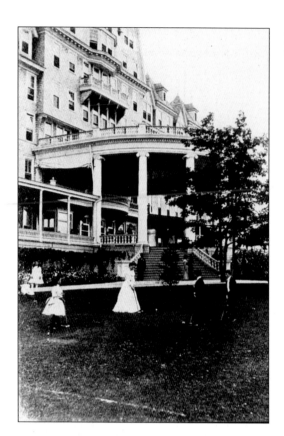

Photographed is the front porch entrance to the hotel.

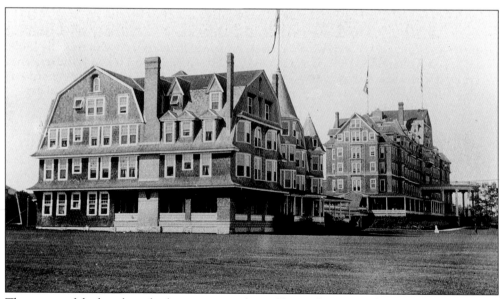

The annex of the hotel was built to accommodate additional guests at the turn of the century.

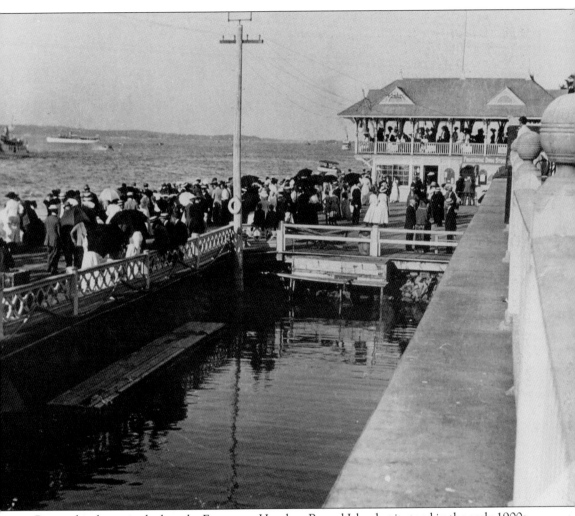

Pictured is the main dock at the Frontenac Hotel on Round Island as it stood in the early 1900s. The first floor of the building shown stands today, and acts as the post office for island residents. Residents of the island began renovations in the summer of 1997 to restore the remaining section of this building and its dock to preserve a piece of this island's unique historical past.

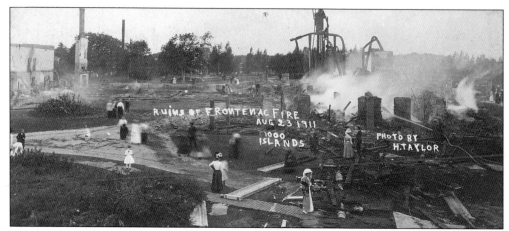

Pictured here are ruins left by the Frontenac fire on August 23, 1911. The annex would also be destroyed by fire in 1917.

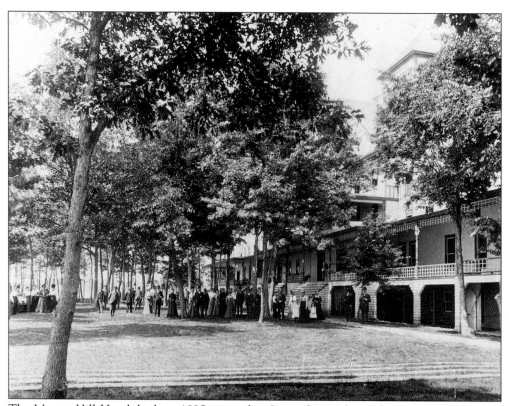

The Murray Hill Hotel, built in 1895, opened in June of 1896 for its first season. This hotel, unlike many others of the era, was never destroyed by fire. The hotel remained in operation until 1925, with a brief closing from 1916 to 1919.

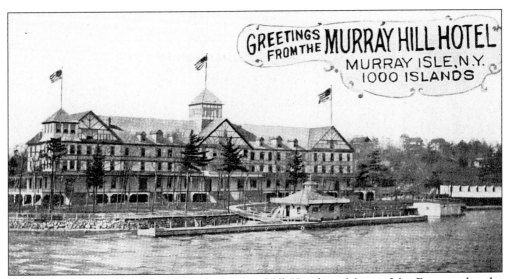

This is an early advertisement for the Murray Hill Hotel on Murray Isle. For two decades following 1925, the hotel remained closed, vacant, and slowly fell into disrepair. Eventually, in the 1940s, the building was torn down.

This photograph of the Hub House was taken from the Thousand Island Park Hotel in Thousand Island Park on Wellesley Island. The Hub House was built to accommodate over two hundred guests.

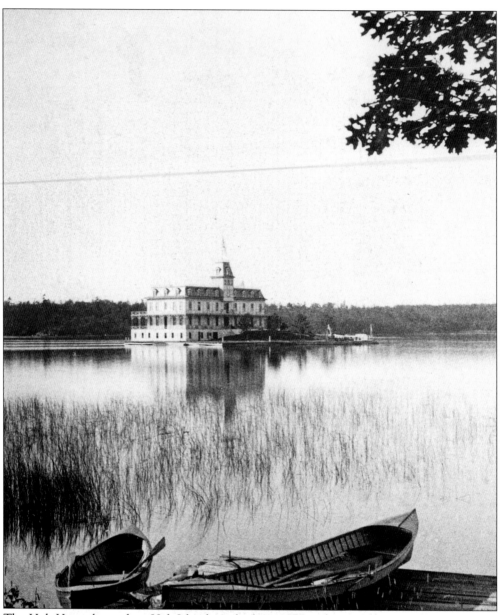

The Hub House located on Hub Island was built in 1877 and operated seasonally until it was destroyed by fire in 1883. This A.C. McIntyre photograph is believed to have been taken from the foot of nearby Grenell Island.

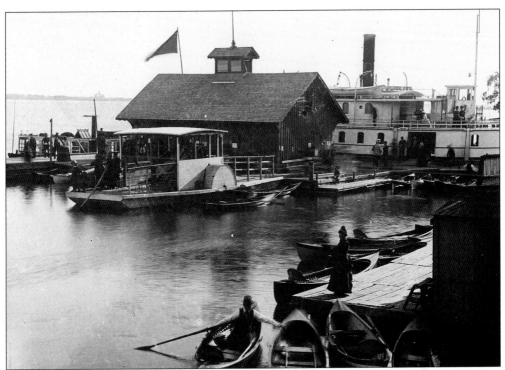

This photograph was taken from behind the boat livery at Thousand Island Park; surrounding the livery are skiffs. Also shown in this picture is the horse ferry from Fishers Landing, in the background passengers board a steamer. The park advertised for visitors to come boat, fish, and "breathe in the ozone" believed to have healing powers.

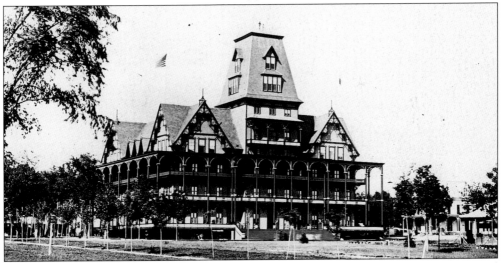

Thousand Island Park boasted two grand hotels of the era. The Thousand Island Park Hotel and the Columbian Hotel operated from 1883 to 1890 and 1892 to 1912 respectively. Each of these hotels also fell victim to fire. Thousand Island Park does not fall within the township of Clayton, but deserves mention because many park visitors would first travel to Clayton by rail to board ferries for this final destination. Ferries were also available in neighboring Fisher's Landing.

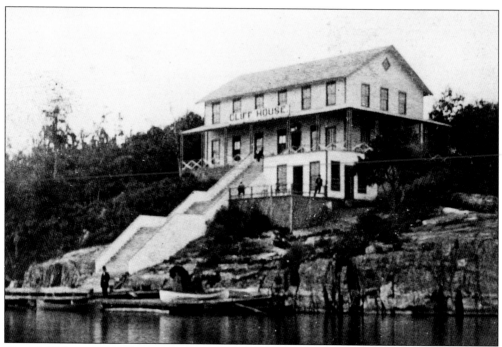

The Cliff House was built near the foot of Murray Isle.

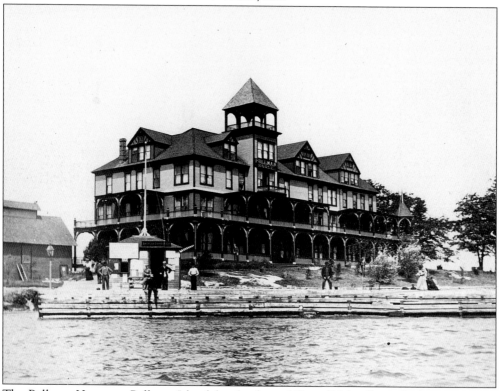

The Pullman House on Pullman Island (at the foot of Grenell Island) was built in 1890 and held 30 rooms for guests. It was destroyed by fire in 1904.

Six

WINTER IN CLAYTON

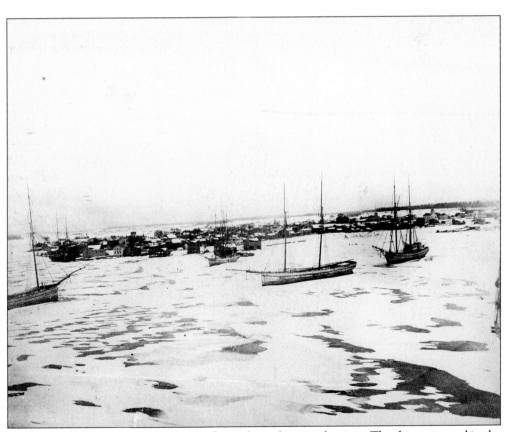

French Creek Bay was a terminal point for timber rafting on the river. The ships wintered in the Clayton harbor. This Bain Brothers photograph was taken in 1872.

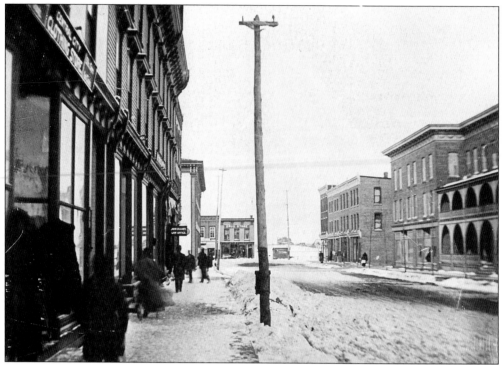

This winter shot of lower James Street was taken sometime after 1895. Shown are the brick Hubbard House, the castle on Calumet Island, and the Ellis Drug Store, which is at the end of James Street on the right.

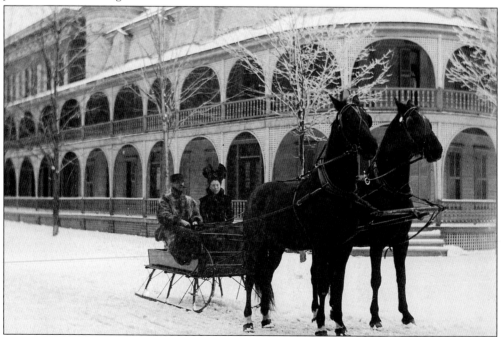

This couple posed with their handsome cutter and team beside the annex to the Hubbard House. This annex was used from 1895 until 1909, when it was destroyed by fire.

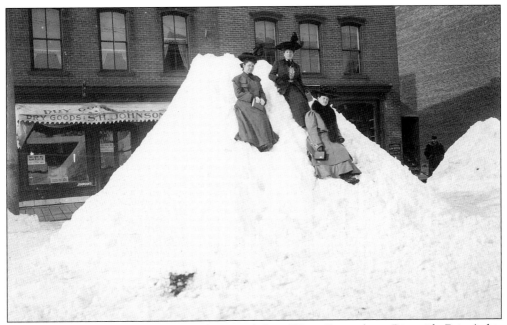

After a heavy snowstorm left heaps of snow piled on Water Street (now Riverside Drive) this trio of well-dressed ladies posed for a photograph.

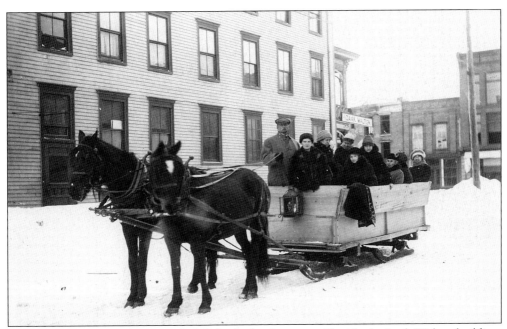

These young folks are enjoying a bobsled ride that has paused beside the Issak Walton building. The three-story building in the background was built in 1916 for the Simon Breslow Furnishing Store, which remained in business until 1942.

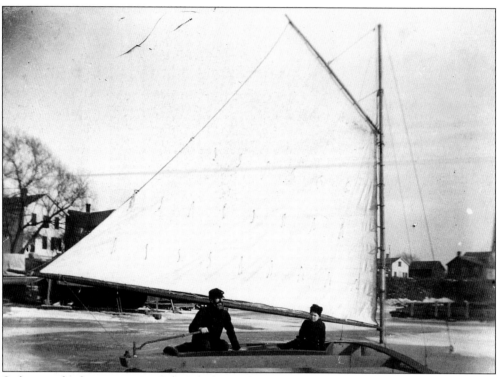

Sailing on the frozen river was very popular in the gay nineties, and remained popular well into the 1950s. Roland Kellogg was known to sail in the 1950s.

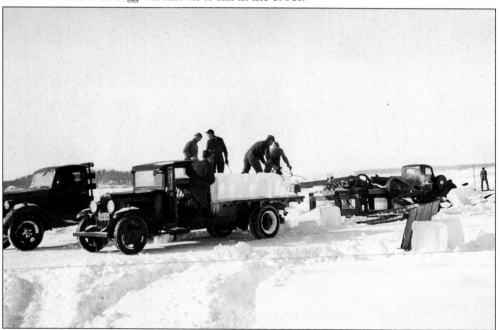

In 1890, ice harvesting was a brisk business. Ice was shipped by rail; one such shipment filled 30 rail cars. It is believed that the people cutting ice in this photograph could be part of the Wallace Kittle operation c. 1930.

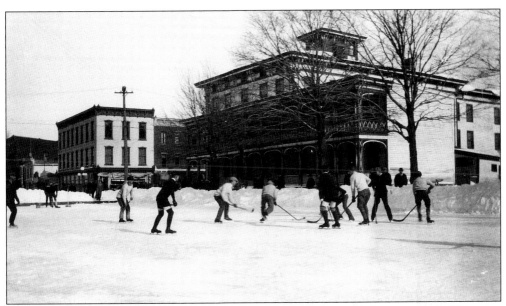

Pictured here are local boys playing hockey in the street on Riverside Drive around 1930.

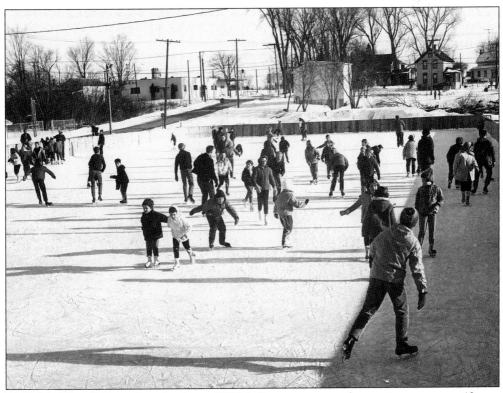

This skating rink located at the foot of Webb Street was one of many in use over a 40-year period. Others were built at various locations around the village of Clayton.

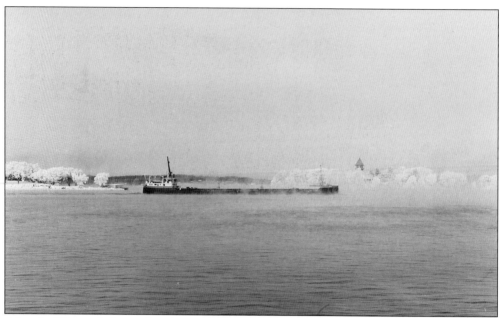

After the lifting of a heavy fog, the trees on Governor's and Calumet Islands are revealed. It is a beautiful sight as a freighter again begins its trip down river.

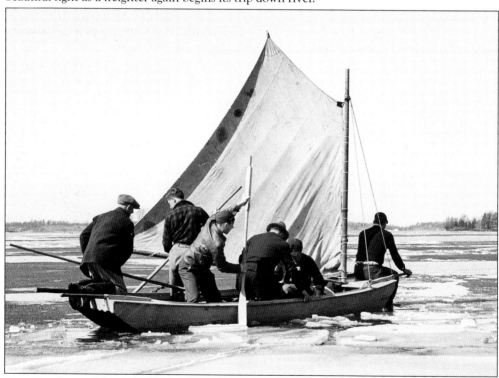

The Grindstone Island mail run is pictured here heading out to cross the channel in 1946. Shown in the picture are as follows: Bob Garnsey, with helpers Emmett Dodge, Jack Garnsey, Manley Rusho, Paul Carnegie, and Lawrence Garnsey. Later, Bob Lashomb and then Francis Garnsey, followed by his son, "Salt," were in charge of these mail deliveries.

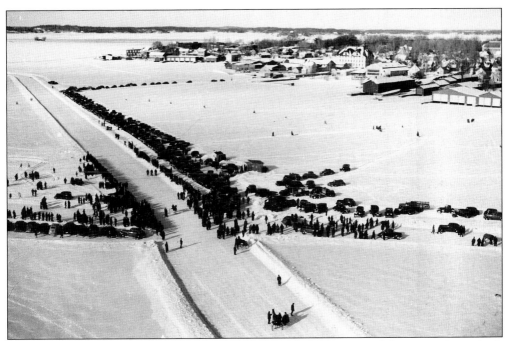

A large number of cars and people gather on French Creek Bay to watch harness racing, which was held on the ice every February for many years, weather permitting. After three days of races, a Horse Trot Dance was held in the town hall, where non-dancers were able to watch from the balcony. This photograph was taken by Les Corbin during the 1940 races.

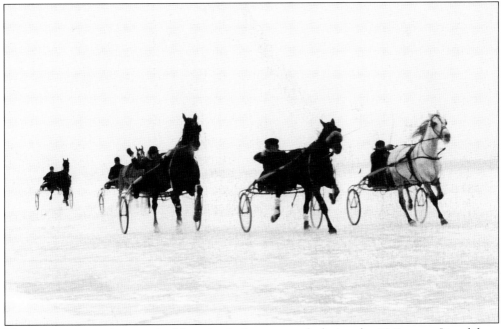

Harness racers are photographed here in the home stretch during the 1941 races. Listed from left to right are as follows: Guy Jr. driven by Garnsey; Just Pete driven by Ed Jones, and Tony Gratton driven by McLear.

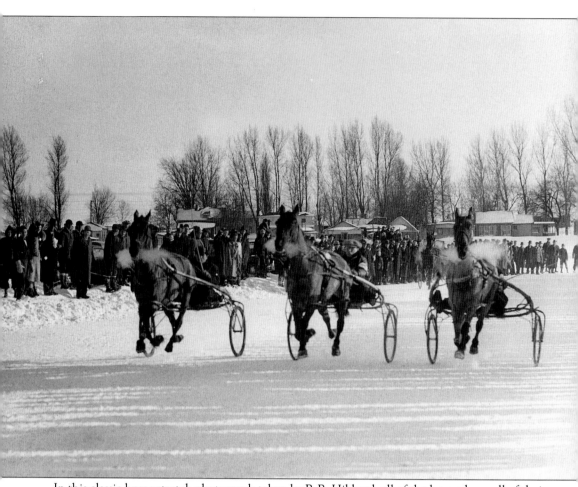

In this classic home stretch photograph taken by R.B. Hibbard, all of the horses have all of their hooves off the ice! This photograph is part of the Corbin Collection courtesy of "Bob."

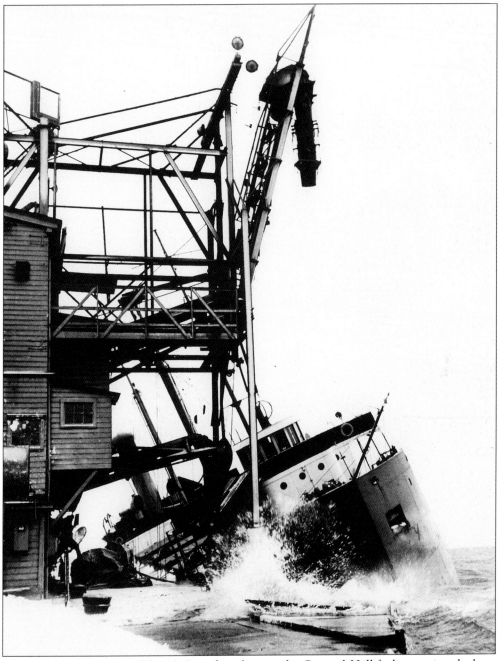

This captivating view is of the SS *Outarde* sinking at the Consaul-Hall fueling station dock on November 30, 1945.

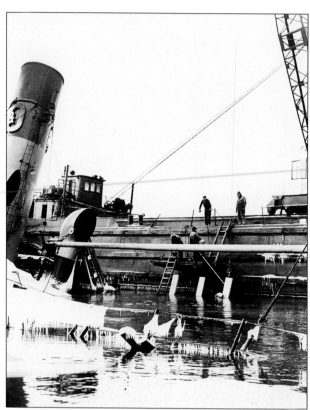

Workers had a difficult time raising the *SS Outarde*. After a failed first attempt, she was finally raised on April 20, 1946.

A classic ice punt is pictured here arriving behind the buildings on Riverside Drive. Listed from left to right are as follows: Key Bank, C.A. Ellis, the Waldron building, and McCormick's restaurant. After the two fires in 1983 and 1988, only the Waldron building, now Uncle Sam Tours, and the Key Bank building are still in existence. In the far left of the photograph you can see the Rothenberg building, now Reinman's decorating.

Seven

THE VILLAGE COMMUNITY

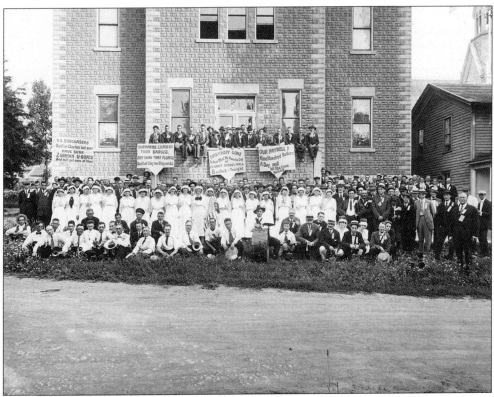

A WW I bond rally is pictured above. Dignitaries, shipyard workers, and Red Cross workers gathered on the steps of St. Mary's School. The school (1907-1970), located on Mary Street, was the site of the present St. Mary's Parish Center.

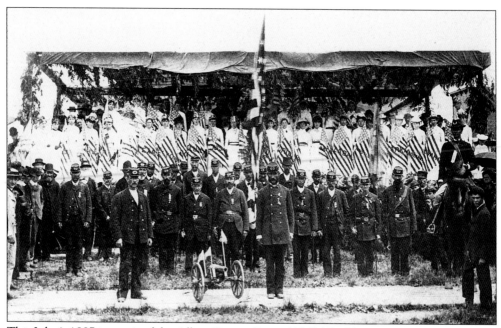

This July 4, 1887 image is of the Albert Dennis Post #410 GAR, Clayton, New York.

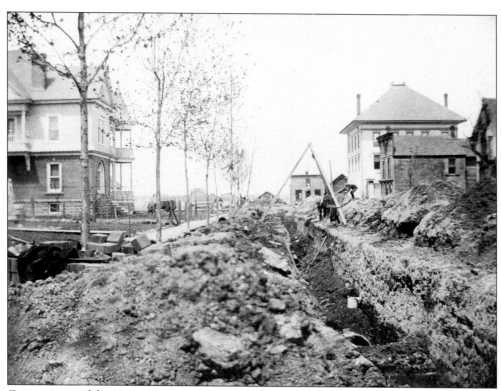

Construction of the sewer on Merrick Street from Hugunin Street to the river is pictured here.

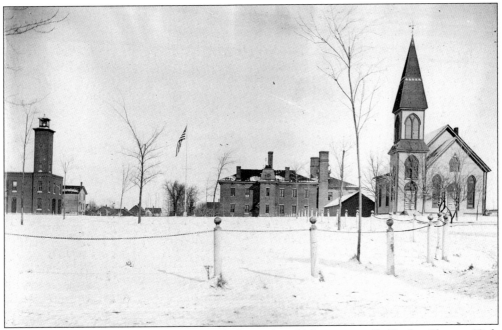

An early view looking east across the park shows the old fire station (left), the Clayton High School (center), and the Baptist church (right).

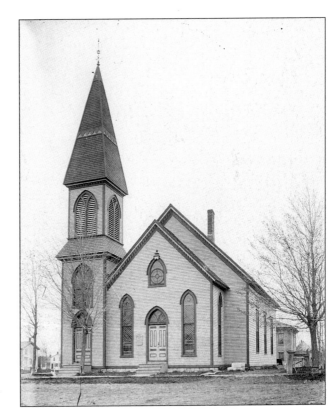

The First Baptist Church was dedicated in 1847, and the first pastor was Reverend Blount. In 1854, there were 118 members. In 1919, lightning struck the tower, and repairs were needed and made. After a second fire in 1924, the church was rebuilt.

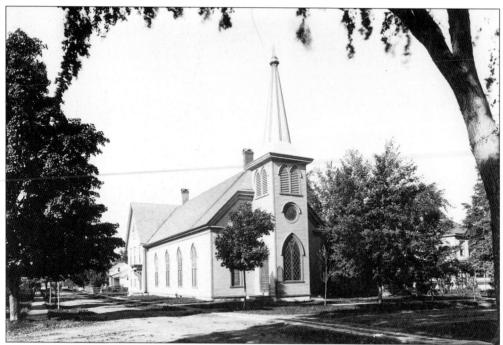

The United Methodist Church on John Street was constructed in 1841 and was shared with the Baptists until 1847. The building has undergone renovations and improvements since.

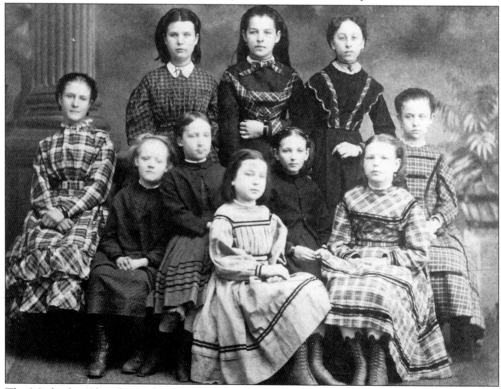

The Methodist Church Sunday school class was pictured here in 1870.

The Christ Episcopal Church was built in 1869 and in use by 1871. This handsome brick structure seats two hundred. The first stained-glass windows date from 1873. Mary Ann Girard and G.M. Skinner were the first couple married there in 1871.

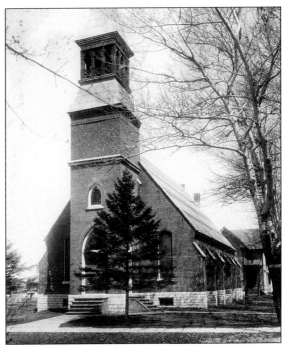

In 1884, the congregation of the old St. Mary's Church (1842-1889) decided to build the present stone church. The dedication was on December 11, 1889. The bell, donated by Peter Fitzgerald Jr., cost $850. Necessary repair has recently been underway on the stone work.

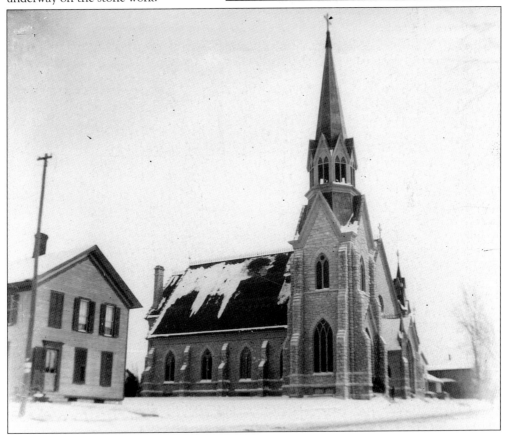

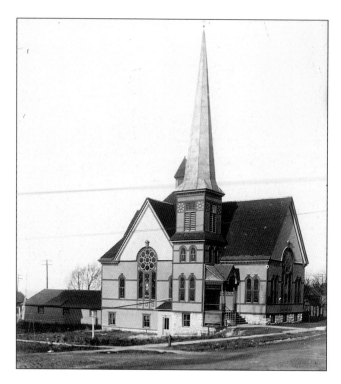

The Congregational Church on James Street was organized on March 17, 1890. Rev. Thomas Hall was the first pastor. Currently, this site is the K. of C. Hall, and is used for bingo, wedding receptions, and various K. of C. activities.

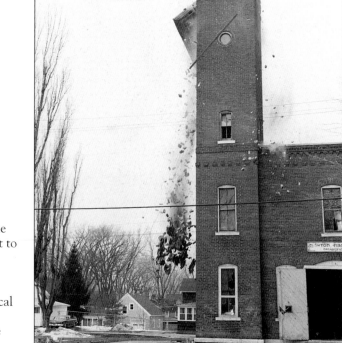

The old Clayton fire hall is being razed in this image. The building was located adjacent to the park, across the street (Mary Street) from the old high school. Bricks for this building were made at the local brickyard that, at the time, was located on the site of the present municipal pool.

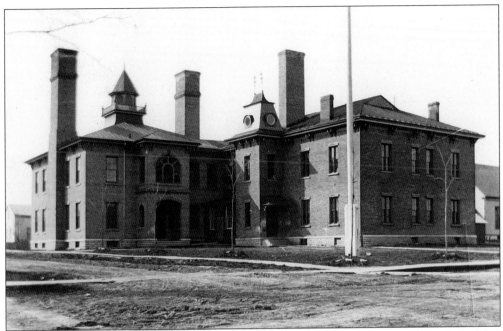

The Clayton High School located on the corner of Merrick and Mary Streets was a remodeled and modernized structure built in 1867 and damaged by fire in 1907.

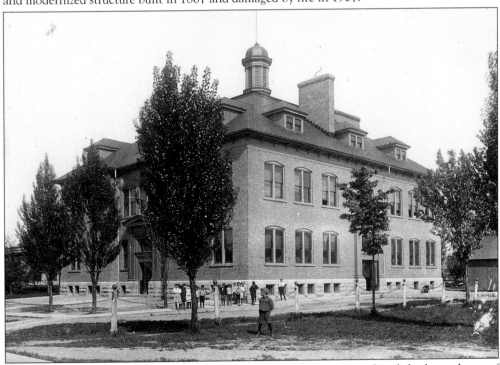

The grades of the school were accommodated in an addition that replaced the burned part of the older building. Clayton Central School on James Street, put into use for graduation 1943, is now a grade school. A merger with Cape Vincent resulted in the Thousand Islands School at Sand Bay.

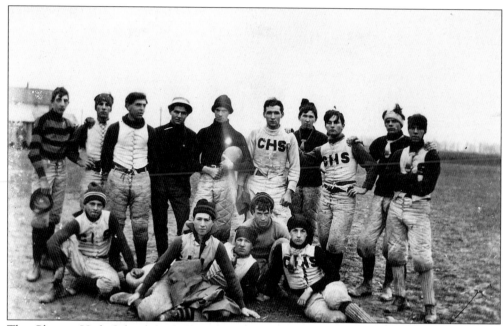

The Clayton High School football team is pictured here. Pictured from left to right are as follows: (front row) Fred Daily, "Ed" O'Toole, Amos Brabant, Everett Howard, and Lawrence Ellis; (back row) "Nick" Riley, Claude Dorr, "Chet" Baltz, "Dutch" Haas, "Tom" Bell, Raney Blanchard, Harley Danforth, "Ed" Buskirt, Clark Hall, and Fred Ladd.

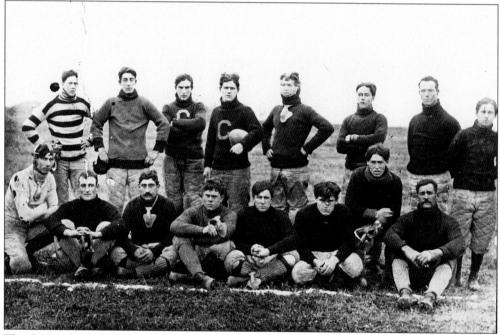

The C.H.S. football team is pictured here c. 1900. Listed from left to right are as follows: (front row) Dan Crowley, Napolean Longton, Eli Roderick, G. Mercier, Amos Brabant, George Hurst, Frank Grant, and George Miller; (back row) Roy Brown, Ed Riley, Wm. Cheney, Harry Waite, Ed O'Toole, Nelson Longton, John Johnson, and Fred Daily.

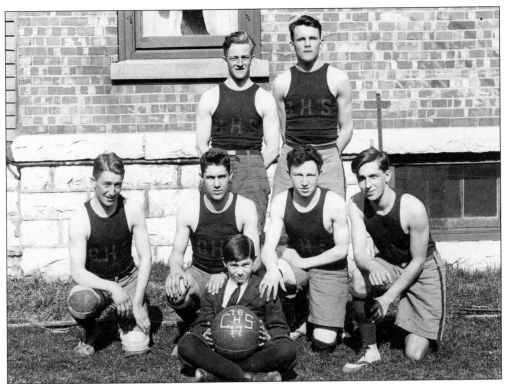

This is the Clayton High School basketball team of 1916-1917.

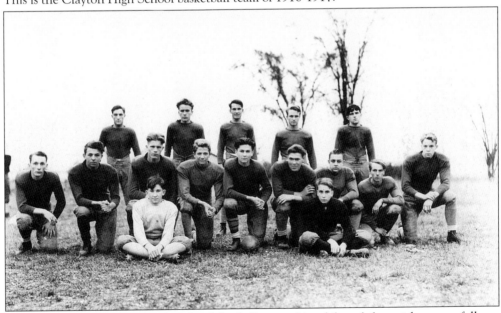

Here is the 1932 Clayton High School football team. Listed from left to right are as follows: (seated in the front row) Art Bennett and Truman Moore; (kneeling in the front row) Roy Carnegie, Clyde Ferguson, John Bates, Albert Natali, Larry Monteith, Dan Garnsey, Floyd Consaul, Wendell Youngs, and Glenn Wilder; (back row) Earl Churchill, John LeTarte, Chuck LaChance, Kenny Brabant, and Gene Slate.

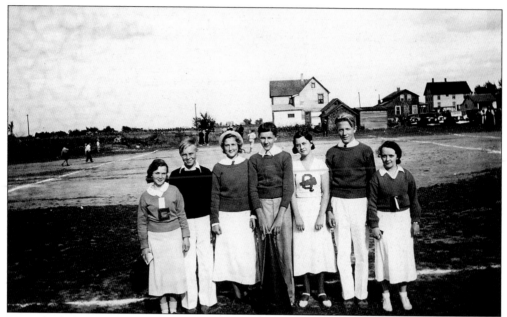

Here are the 1933 C.H.S. cheerleaders: Elaine Morse (Ford), Lucy Bates (Hutchinson), Helen Gifford (McAvoy), and Ruth Bell (Phillips). Football games were played on the Emery Field.

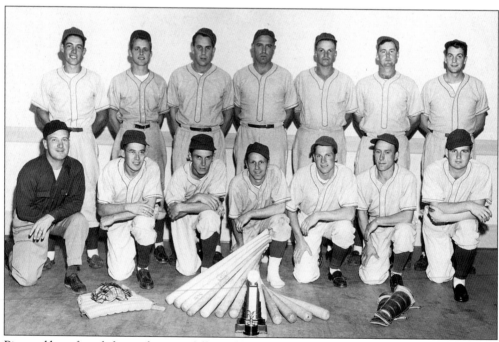

Pictured here from left to right are as follows: (front row) Mgr. Winslow, Capt. Jerry Wetterhahn, Lloyd Higgins, "Kilroy" Youngs, Stan Palmer, Tom Fitchette, and Dick Ingerson; (back row) Al Lawrence, Wayne Youngs, Les Palmer, Harold Mason, Allen Mitchell, M. Kenny, and Jr. Kittle.

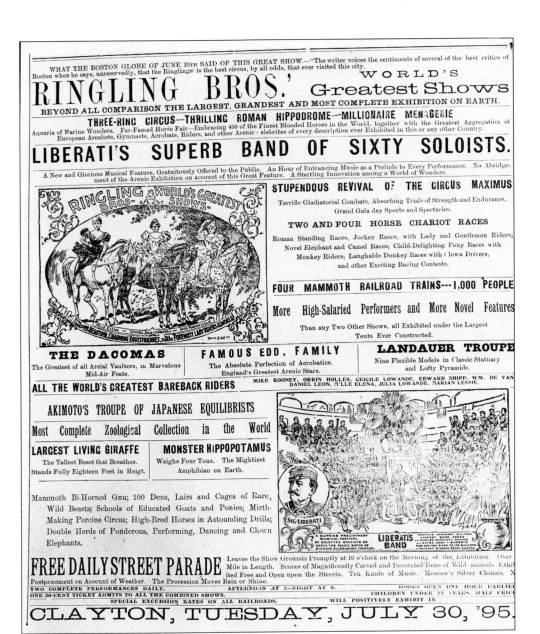

The Ringling Bros. Circus came to town in 1895. An article in *On the St. Lawrence* on July 12, 1895 read, "Advertising car No. 1 of Ringling Bros. Circus reached town Tuesday. Two more cars will come before the circus makes an appearance."

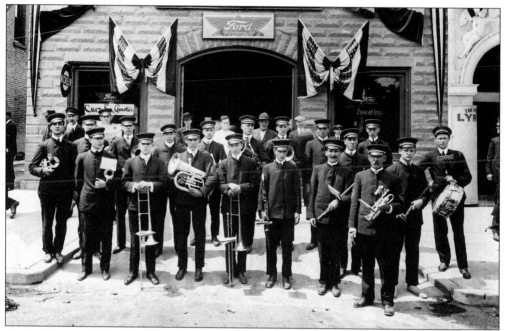

Pictured here is a band in front of the Ford Garage on James Street. The Lyric Theater is to the right. During the mid-1800s, a Clayton Cornet Band was formed, although this band is not identified as such.

This home talent show was held in the old town hall. Other events held here were graduations, dances, and public meetings.

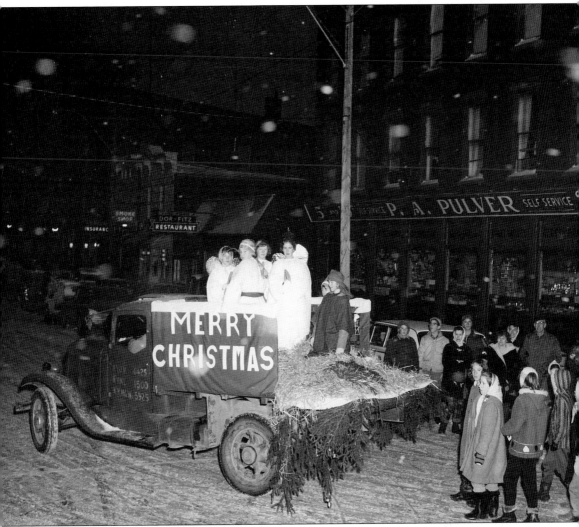

One of the first Christmas parades lingers in front of P.A. Pulver, which was located on the corner of James Street and Riverside Drive. This site later housed Kennedy Pharmacy and currently Upriver Cargo Antiques.

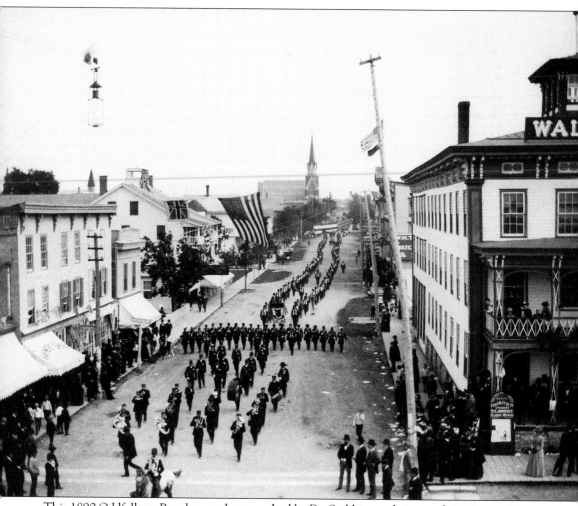

This 1890 Oddfellows Parade was photographed by Dr. Stebbins and gives a clear view up James Street. The Clayton Oddfellows Lodge No. 539 was instituted in 1886.

This south side photograph of Water Street looking east shows the railroad depot in the distance.

This is an image of the north side of Water Street looking west from C.A. Ellis Co.

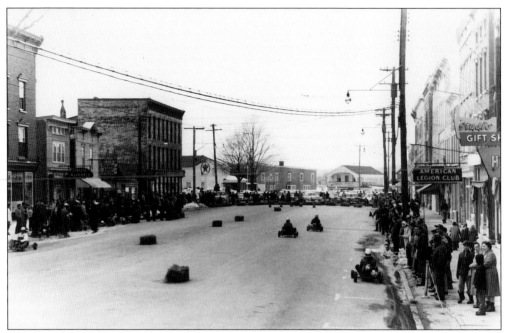

This photograph of the go-cart races records two long-gone businesses. At the end of Riverside Drive are the Hutchinson rooming house and McCormick's Snack Bar.

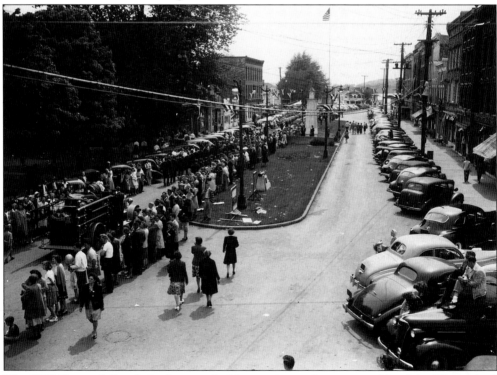

The 1947 Fireman's Parade is photographed here as it marches on one side of the "Cucumber" park on Riverside Drive. In this photograph you can see one of the park's cannons and the WW II memorial. The park was removed around 1950.

Eight

THE PEOPLE OF CLAYTON

"Aunt Jane" was Jeannette Marshall Johnson, born in Scotland in 1794. She settled on Grindstone Island with her husband, Samuel, at age 23, in a location now known as Aunt Jane's Bay, where Johnson was employed in the lumber trade. At 96, Aunt Jane visited friends in Clayton and attended the Oddfellows Memorial Services (1890).

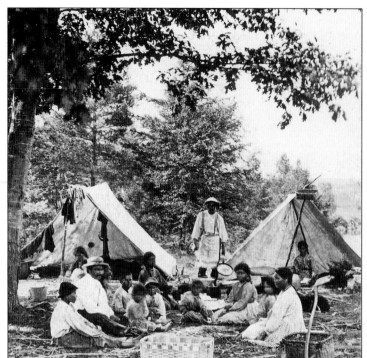

The Native Americans on Grindstone Island had at least two villages there. This region was a summer resort for them; their regular residence was near the many lakes in Central New York. The Oneidas, Onondagas, and Mohawks, all members of the great Iroquois Nation, held the lands here after the revolution. Arrowheads and other artifacts found here by Marshall Farrell were displayed at the old town hall museum.

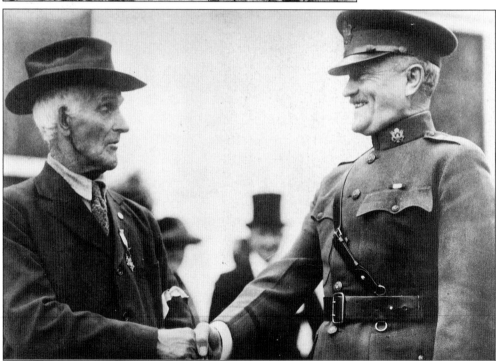

Joseph Lonsway is pictured here being greeted by General Pershing at ceremonies for the Unknown Soldier on November 11, 1921. Mr. Lonsway was the recipient of the Congressional Medal of Honor, received for valor at Murfree Station, Virginia, on October 16, 1864, and awarded in 1917.

Copied from an old tintype, this photograph shows Civil War soldier Jake Bazinet with a friend.

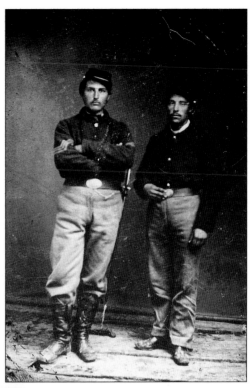

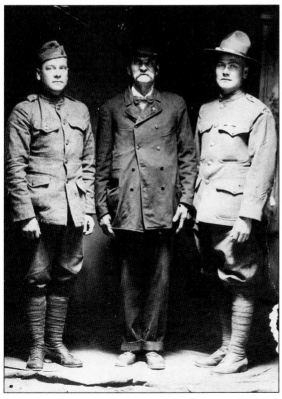

Josh Calhoun, a Civil War veteran, is pictured here with family members Ernest and Arthur, in WW I uniforms.

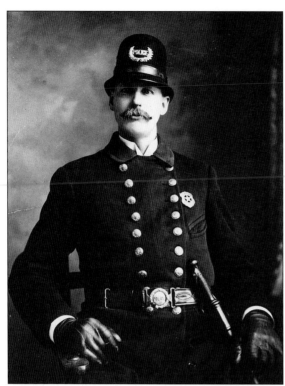

Jay Alexander was a Clayton constable at the turn of the century. S.S. Beck, the photographer, maintained a gallery on Webb Street in 1894.

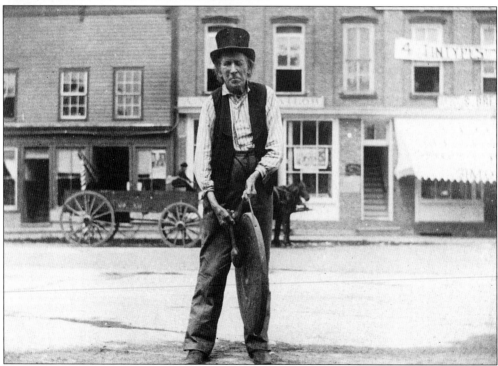

Patrons of early hotels were given "room and board." Dinnertime at the Walton House was announced to shoppers and strollers by "Squealing Jim" Johnson with this large gong.

Gordon Bennett is pictured here with his sister. Bennett, a Clayton businessman, was well known for his interest in history and duck decoys. Note the wooden sidewalk and, in the distance, the north side of Riverside Drive.

Mr. Cummings was the principal of Clayton High School for 30 years, and he also taught the classes in Chemistry and Physics.

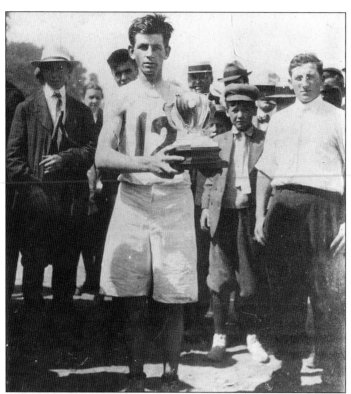

George Hutchinson (1889-1979) of Clayton is pictured here holding the first place cup for the 10-mile race held in Gananoque in the early 1900s. At his left, is Ned Hambly and on his right are Ray Seymour, David Perry, and Ray Stalker. A daughter Ann lives in Clayton.

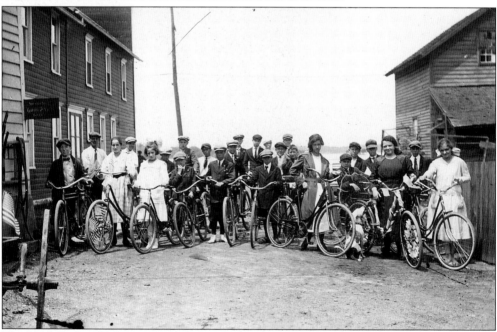

The 1915 Cyclers Club is pictured above. Cycling became a popular pastime in the early 1890s. An item in May 1894 invites all cyclers to an organization meeting at the depot with a special invitation to lady riders. The same year, F.L. Hall and W.D. Clark made a 347-mile round trip ride from Clayton to Montreal in a week.

This is an early Methodist Sunday school class in Clayton.

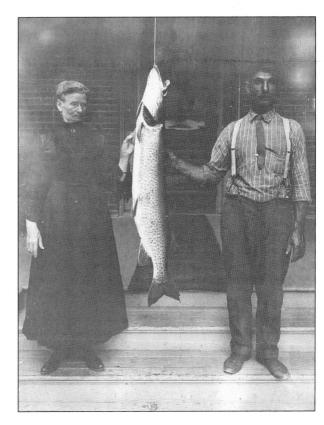

Mrs. Mann and her guide, Charlie Seymour, pose with a muskellunge, the trophy fish of the St. Lawrence.

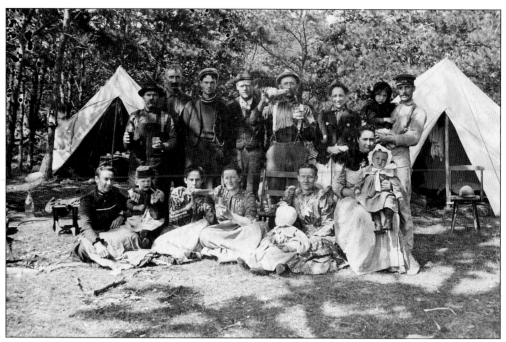

Around 1900, Clayton family groups and friends enjoyed camping at Bartlett Point. Working men would row over to the village crossing French Creek Bay each day.

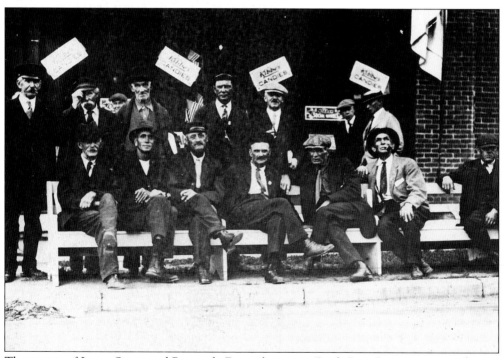

The corner of James Street and Riverside Drive, known as Rock Bass Corner, was a gathering place for guides and oarsmen.

Another popular place for the fishing guides was on the steps of Dick LaPort's barbershop on James Street.

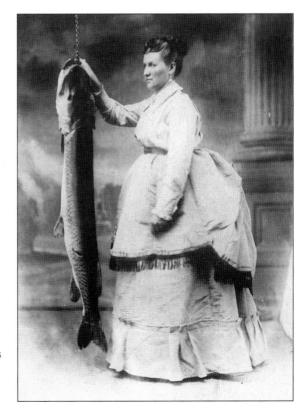

Mary Ann Skinner, a great fisher-lady, probably caught this muskie with one of her husband's famous "Skinner Spoons." Her husband, G.M. Skinner, operated a business in Clayton, manufacturing and selling fishing lures and spoons. At the 1893 Columbian Exposition in Chicago, Skinner won an award for his famous fishing lures.

"Pop" Cameron was in charge of the Clayton Casino, where he booked in some of the popular "swing" bands. This popular dance spot closed during WW II.

Singer Maxine Andrews of the Andrews Sisters is pictured here in the Herald House lobby with Harold Bertrand (left) and her husband. Maxine liked to fish the St. Lawrence River with guide Roland Garnsey Jr.

John "Fa" Pacific is pictured here in a dive from the Consaul Hall Fuel Station near the railroad depot.

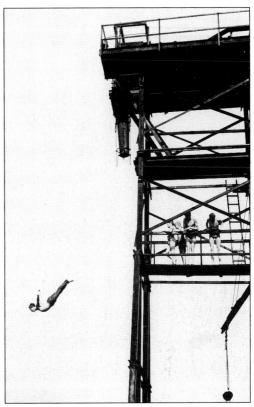

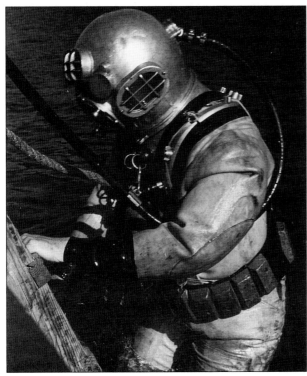

Perry Hazelwood, a well-known diver in the area in the early 1940s, had his dive suit made to order for his 6-feet 4-inch frame.

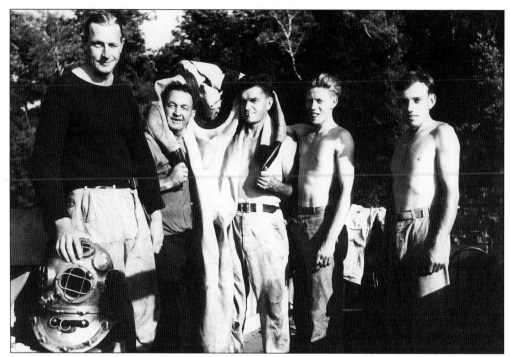

Perry Hazelwood is pictured here with his crew. Identified in this image are Perry (left), Donald Gray (center), and John Flood (far right). A caption from the local paper dated November 25, 1943, read, "Perry Hazelwood and Don Gray have completed diving operations for the removal of a water pipe at the rear of the old pump station. The village board will sell about 500 feet of 12-inch salvaged pipe. The men have also found a 24-inch square of hand hewn white oak timber 38 feet long. This is believed to have been in the water over 100 years since a shipyard was located on the site where the town hall stands."

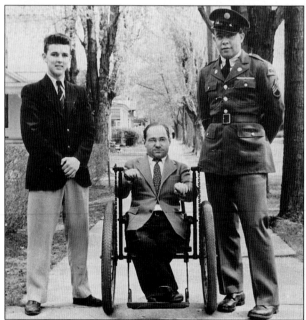

This WW II photograph shows Jim Thibault, Les Corbin, and Glenn "Cheeser" Wilder.

Scuba divers and a salvage crew are pictured here with an old anchor. Capt. Gordon Hutchinson (far right) was a tour boat captain for many years.

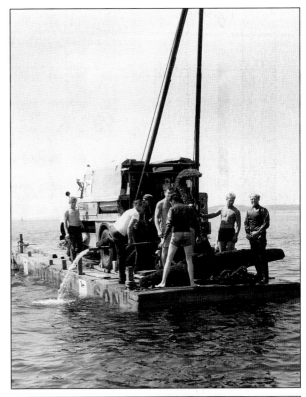

Lawrence Balcom captained *The Island Princess*, running tours from Corbin's dock prior to and after 1950. Here he is pictured with Little Johnny of Philip Morris fame.

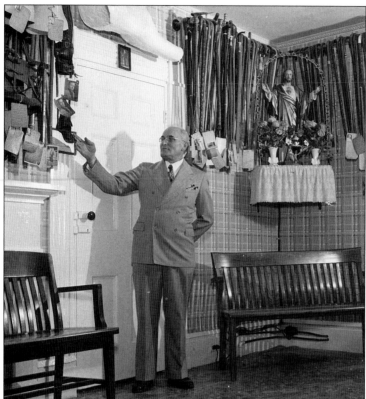

Antoine Tetrault (1881-1963) came to Clayton as a "miracle worker." His healing touch benefited many as shown by the many canes, crutches, and braces left behind when no longer needed. His home was on John Street, site of the Thousand Islands Craft School, where a room is maintained in his honor.

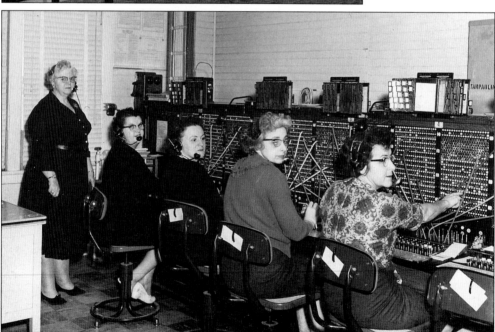

Pictured above are telephone operators at work. The local telephone company was located opposite the old town hall on Riverside Drive. Shown are Marie Hanratty, Frances Ierlan, Eleanor Ireland, Irene Guyette, and Helen LaLonde.